DATE DUE

AG 18 '84			
3 OCT 1986	Ang Pd		
1 8 APR 1988			
MAY 2 8 2002			
JUL 2 1 2003			
	201-6503		Printed in USA

Christo: Wrapped Walk Ways

Loose Park, Kansas City, Missouri, 1977–78

Essay by Ellen R. Goheen
Photographs by Wolfgang Volz

Harry N. Abrams, Inc., Publishers, New York

The documentation exhibition of drawings, technical data, and photographs for *Wrapped Walk Ways* was sponsored by the Contemporary Art Society of the Nelson Gallery, Kansas City, Missouri.

The *Wrapped Walk Ways* project was paid for totally by Christo through the sale of his original drawings.

Library of Congress Catalogue
Card Number: 78-20619
International Standard Book
Number: 0-8109-0762-3 (H.C.)
 0-8109-2191-X (pb.)

Designed by Christo
Text © 1978 Harry N. Abrams, Inc.
Project Photographs © 1978 Wolfgang Volz
Editor: Edith Pavese
Design Coordinator: Patrick Cunningham

Published in 1978 by Harry N. Abrams, Incorporated, New York
Printed and bound in the United States of America

CHRISTO: WRAPPED WALK WAYS

Christo was invited by the Contemporary Art Society of the Nelson Gallery to come to Kansas City with the hope that he would do a project. In October of 1972, there had been an exhibition of works from Christo's *Valley Curtain* at one of the commercial galleries in the city. Christo had been present for the opening of that event and subsequently had been in the city several times, so he was somewhat familiar with its character. Before his arrival in October 1977, those who would show him the city tried to anticipate his interest and to determine those areas which might be of serious consideration for an eventual project. Two kinds of places came to mind immediately: the Missouri River and the parks. Christo chose the parks. If one physical feature of Kansas City stands out, it is its lavish amount of green spaces designed by George Kessler, a student of Frederick Law Olmsted.

Luckily Kansas City had foresighted planners in its early days. Two men in particular, August Meyer and William Rockhill Nelson, cared enough about the makeup of the city to ensure a sound skeleton of parks and boulevards which to this very day make Kansas City one of the most pleasantly livable urban centers in this country. In fact, by 1915 the system of parks and boulevards had assumed the shape it would take for the next half century with only minor additions.

On October 29, 1977, Christo arrived for a look at the city. After viewing several park areas, he decided upon Jacob L. Loose Memorial Park for the very simple reason that people use it. They come in great numbers. It is a small park of 74 acres set in a beautiful and serene residential area with the curious name of the Country Club District. The park was, in fact, part of the golf course and polo grounds of the Kansas City Country Club, which had its site here until the late 1920s.

In 1927 the land, which had been purchased by Mrs. Jacob L. Loose for $500,000, was given in her late husband's memory to the Parks Department and the citizens of Kansas City. The area bears further historical significance as the site of the largest and one of the bloodiest of the western campaigns of the Civil War, the Battle of Westport, which took place on Sunday, October 23, 1864. Markers relating the details of these events dot the area.

The park is characterized by both English and French tendencies for ordering open natural spaces. In the northern quadrant one finds a formally organized system of plantings, flower beds, rose arbors and pavilions. The

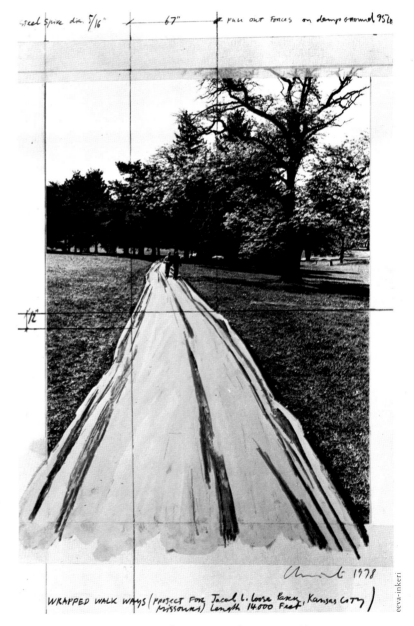

Wrapped Walk Ways (Project for Loose Park, Kansas City, Missouri), 1978. Enamel paint, pencil, and ballpoint pen on photograph. 15 x 9½". Private collection, Hamburg, West Germany

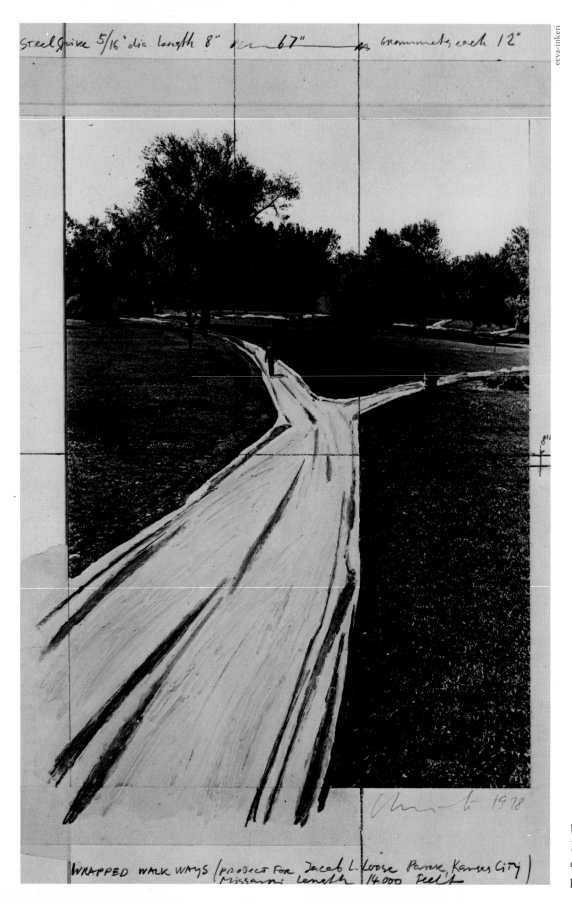

eeva-inkeri

Wrapped Walk Ways (Project for Loose Park, Kansas City, Missouri), 1978. Enamel paint, crayon, pencil, tape, and ballpoint pen on photograph. 15 × 9½".

remainder of the park incorporates a pond with rolling hills planted with clumps of trees in the English manner. The perimeter of the entire park is marked by jogging paths. Thus, one area is rigidly formal and the other openly meandering in form. This contrast was made more evident by Christo's unifying covering of saffron nylon which united all footpaths into a cohesive whole. The density of material at the north end of the park covering the abundant paths within the formal plan offered a counterpoint to the sweeping aspect of the perimeter walks of the southern regions.

Christo had hoped to accomplish a large-scale wrapped walk way project for nearly a decade. This fact was unknown to the Contemporary Art Society at the time it offered its invitation.

The evolution of the wrapped walk way idea is intriguing and although its park aspects stemmed most immediately from a trip Christo took through the Far East in late 1969, on his return from Australia, it has origins in his own work antedating that experience.

Perhaps the first seed of the idea came with the artist's *5600 Cubic Meter Package* for Documenta 4 in Kassel in 1968. Several attempts were made before the successful erection of the 280-foot-high sculpture—the world's tallest inflated structure. During one of these attempts, while the polyethylene skin was spread out inside the network of ropes on the ground, the idea of covering a pathway came to mind.

After the new Museum of Contemporary Art opened in Chicago, its director, Jan van der Marck, asked Christo to make a proposal for wrapping its exterior. He agreed to this if he could also do a horizontal piece inside. Both the proposal for the exterior and the wrapped floor became a reality in 1969. Thus, the floor of the lower exhibition area was wrapped using 2800 square feet of painters' dropcloths. For the most part they were loosely laid, overlapping one another and were secured to the piers within the space by ropes. These 12 x 16' cloths which had been industrially laundered were redolent with the scent of the cleaning solvents and splashed with faded spots of paint. Both elements created an additional dimension for the work.

Two more floor pieces were realized in 1969: *Wrapped Floor* in the artist's studio in New York and *Wrapped Floor* and *Wrapped Staircase* in the Wide White Space Gallery in Antwerp.

Also in 1969, the first large-scale wrapping of a natural form took place when the artist accomplished the *Wrapped Coast—One Million Sq. Ft.* at Little Bay, Sydney, Australia. This project had grown from a proposal in 1968 for *Packed Coast (Project for the West Coast)*. The collages made for the West Coast proposal show gentle hills near the ocean and not steep cliffs as the Australian setting would prove to be. The greater part of the Little Bay work involved the covering of the rocky cliffs of the coast, but there was also a small amount of coastline which was not vertical and upon which the public could walk. The excitement of walking over uneven, rocky out-

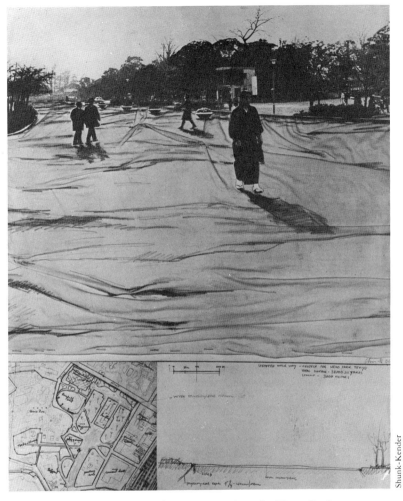

Wrapped Walk Ways: Two Parks Project (Project for Ueno Park, Tokyo, Japan), 1969. Collage: photostat, pencil, crayon, and fabric. 28 × 22". Private collection, Paris

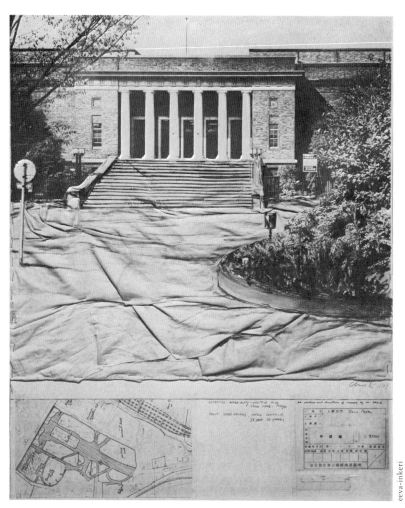

Wrapped Walk Ways: Two Parks Project (Project for Ueno Park, Tokyo, Japan), 1969. Collage: photostat, pencil, crayon, and fabric. 28 × 22".

eeva-inkeri

croppings whose treachery was made greater by the obscuring fabric seemed to lure many to try it. In spite of the danger, there were no mishaps reported by those who chose to participate in the project in this active fashion. The covering signified its own danger and the walker took extra care in his perilous promenade. Once installed, the piece remained for five weeks.

Coming and going from Australia to the United States Christo and his wife, Jeanne-Claude, traveled through the Near and Far East. This experience reinforced the artist's desire to cover walk ways. While in Burma, Thailand and Cambodia, he became very aware of the inhabitants' obvious sympathetic use of the gardens. They were very attuned to their surroundings, especially to the surfaces upon which they walked.

In these gardens, textures are planned to change frequently and subtly. Sand, gravel, water, rocks, vegetation are all consciously arranged to provide subtle transitions of environment. Not dissimilar aesthetic patterns are employed in the design of occidental gardens, but less remarkably so than in the East, and visitors to our parks are less inclined to notice the subtleties of change that do exist within the grand overall effect.

After Australia, a large international exhibition was to be held in Arnhem, The Netherlands. For his part of the exhibition, Christo proposed a wrapped walk way project for Sonsbeek Park. Since the exhibition coincided with the twenty-fifth anniversary of the Battle of Arnhem in which the allies suffered a great number of casualties, the Queen had planned elaborate commemoration celebrations, some of which were to take place in the park. The timing of the two events conflicted and permission to do the project was denied.

One of the most intriguing factors of the Sonsbeek project was that it was to have a companion piece installed simultaneously six thousand miles away in Ueno Park in the middle of Tokyo. Again, the impetus was an invitation to an exhibition, the Tokyo Biennale, which, in spite of the name, does not occur regularly. Rather than passively enter a piece already done, Christo proposed to do a project as his participation in the exhibition. Thus, the *Wrapped Walk Ways: Ueno Park Project* was proposed. The conception was grandiose, for ideally, one would have seen them both.

Sonsbeek is a large park in the northern part of the city of Arnhem. Laid out in early nineteenth-century Romantic style, it is characterized by streams, ponds and cascades and is sparsely used. Ueno Park, once a nobleman's domain, is situated in the bustling center of Tokyo. Along with Shiba Park, Ueno contains the tombs of most of the Tokugawa Shoguns and was opened to the public after the Restoration. Many of the important cultural institutions of Tokyo, the National Museum, the Museum of Western Art, the Concert Hall, the Museum of Natural Sciences and the zoo, among others, are situated in or near the park.

A combination of unfortunate coincidences unrelated to Christo's

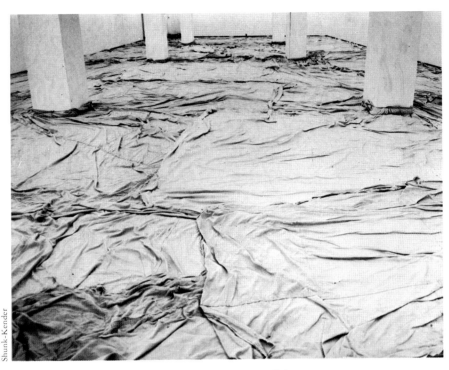

Shunk-Kender

Wrapped Floor, Museum of Contemporary Art, Chicago,
1968–69. 2800 sq. ft. of dropcloths.

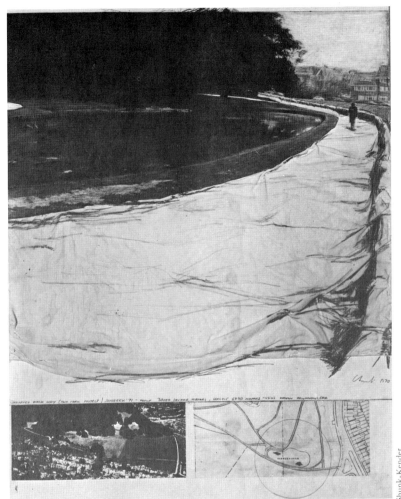

Shunk-Kender

Wrapped Walk Ways: Two Parks Project (Project for Sonsbeek,
Arnhem, The Netherlands), 1970. Collage: photostat, pencil,
crayon, and fabric, 28 × 22″. Collection Mr. and Mrs. William
D. Wixom

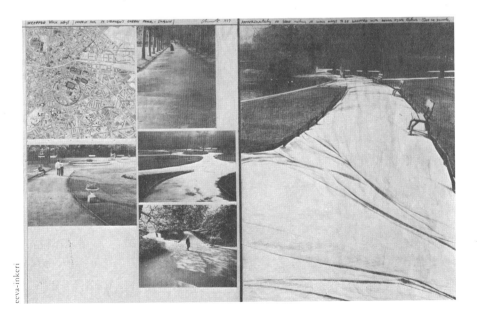

eeva-inkeri

Wrapped Walk Ways (Project for St. Stephen's Green Park,
Dublin), 1977. Collage in 2 parts: photostat, pencil, pastel,
fabric, and photograph. Each part 28 × 22″. Collection
National Gallery, Dublin

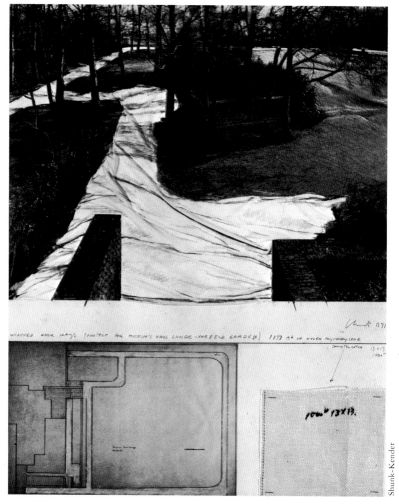

Wrapped Walk Ways (Project for Haus Lange Museum, Krefeld, West Germany), 1970. Collage: photostat, pencil, crayon, map, and fabric, 28 × 22″. Collection Kaiser Wilhelm Museum, Krefeld, West Germany

proposal kept the Tokyo portion of the project from gaining the permission of the Parks Commissioner. Further entreaties were impossible and the project could not be realized within the time limitations of the exhibition.

Unlike Arnhem and Tokyo, the Loose Park proposal had no specific time frame for completion. The exhibition in the Nelson Gallery was an adjunct of the project, not an impetus for it. Contained in the exhibition were thirty-two original works, a series of eighteen photographs of the installation and the finished work, as well as documentation of the technical decision-making process which allowed it all to happen.

Finally in 1971, a small wrapped walk way was accomplished in conjunction with another project. In Krefeld, West Germany, at the Haus Lange Museum, the temporary exhibition space for the Kaiser Wilhelm Museum, the exhibition, *Wrapped Floors, Wrapped Walk Ways,* was installed from May 1 to June 27. The genius of this house designed by Mies van der Rohe in 1928 for Ulrich Lange is found in its integration of indoors and out. In the project, Christo separated inside and out by blocking up the windows with a brown paper covering secured with masking tape. Inside the two-story house he wrapped the floors of the ground story. Outside, he covered the 100-meter walk with a beige-gray synthetic fabric of extremely inelegant character. In comparison to the Loose Park project, its fastening was hastily devised. It consisted of a system of ropes run through seams which were then fastened with wooden spikes. This seems primitive in comparison to the carefully seamed and brass-grommeted arrangement used in Kansas City. The latter system allowed for the artist to carefully control the line of the foot path and the draping of fabric within it. The fabric in Loose Park was cut thirty percent greater than the lateral dimensions of the path it was to cover. The color of the Krefeld fabric was not so satisfactory as the luminous saffron yellow used in Loose Park. The choice of this color is perhaps the single most important aspect of the success of the Kansas City project. The immense extent of the Loose Park paths, 40 times greater than the simple path at Krefeld, is staggering.

Dr. Paul Wember, Director of Haus Lange Museum, commented that the installation of the fabric at Krefeld intensified the differences among the park's components. The trees, bushes, grass, all became disunified and separate with the intensifying line of the walk way. Such a feeling was not evident in Loose Park. If anything, the golden line unified the elements of the park. The disparate materials of the walk ways, cement, asphalt, gravel, grass, were made one by the overlay of the luscious fabric. In the already formal rose garden in particular, one felt a cohesion of elements that is not present without the fabric.

In one respect Krefeld and Kansas City were exactly the same. The sense of everyday reality was destroyed. Pavilions were transformed into oriental temples and gardens into carpets. A sense of intimacy was created everywhere. In an open, public space, the immediate impulse was to sit

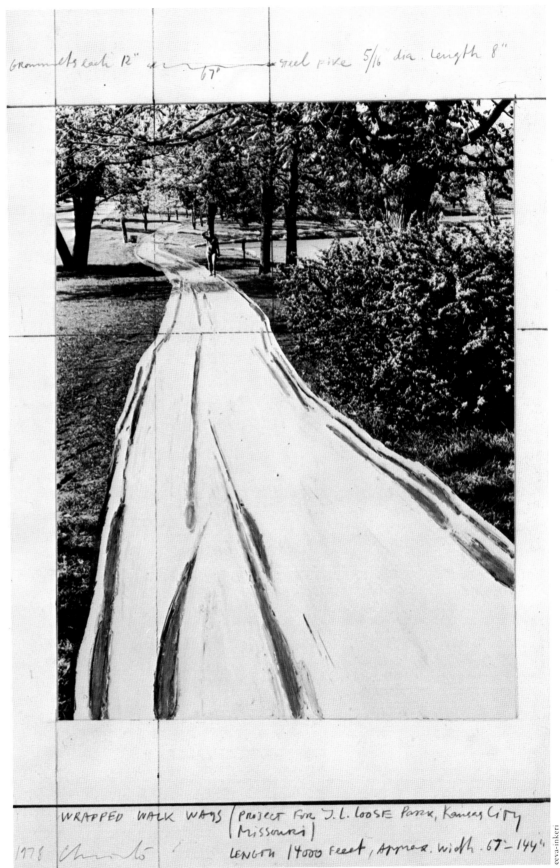

Wrapped Walk Ways (Project for Loose Park, Kansas City, Missouri), 1978. Enamel paint, crayon, pencil, ballpoint pen on photograph, 15 × 9½″.

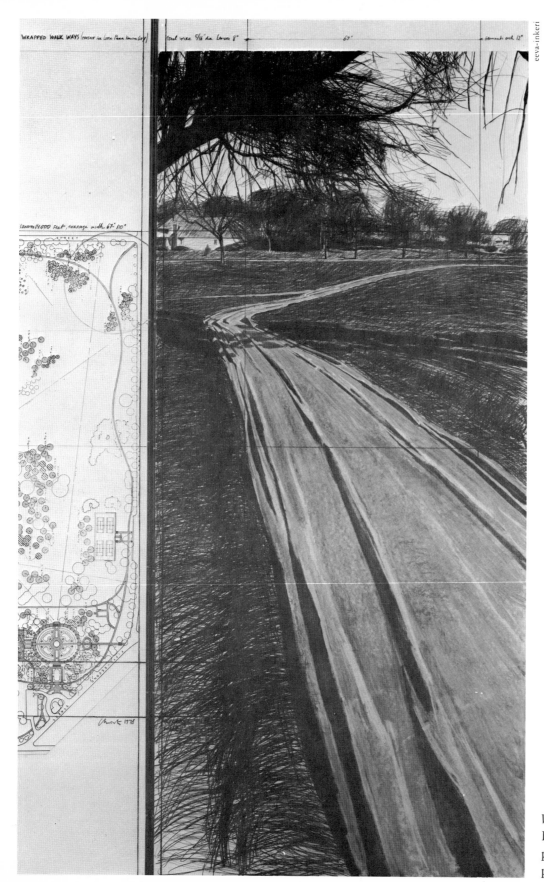

Wrapped Walk Ways (Project for Loose Park, Kansas City, Missouri), 1978. Drawing in 2 parts: pencil, crayon, charcoal, ballpoint pen, and map, 96 × 15″ and 96 × 42″.

down, to remove one's shoes and stockings and walk barefoot on the fabric. On the gradual inclines of the southern regions of the park, small children instinctively sat down and attempted to slide down the succulent surface.

In 1976, a final attempt was made to do a large-scale walk way. This time the place was Dublin, Ireland, in a small park in the city center called St. Stephen's Green. The park is smaller than Loose Park. Christo was again invited to an international exhibition, ROSC, which occurs every four years. *Rosc* is a Gaelic word meaning "the poetry of vision." Works included in the exhibition, which is chosen by a committee of three or four international art historians with an Irish chairman, span the ages from the Migration Period to the present. Instead of lending a piece, Christo again offered a project for the city. This was just after *Running Fence* in California and not enough time had been allotted to the proper planning and groundwork to ensure permission from the Parks Commissioner, who, interestingly, was also a trustee of the National Gallery where the exhibition was to be installed. Again, permission was not granted.

The task of obtaining permission to use the park in Kansas City was relatively easy. The Contemporary Art Society, chartered in 1977, wanted to initiate an event which would be a part of the mainstream of 1970s art and which would physically be part of the public domain and not strictly contained within the walls of the Nelson Gallery. Although fraught with controversy, the latter hope reflects accurately the focus of much art of the twentieth century. The traditional bounds of art have been broken. Art in our era is a social agent more than it has ever been in the past. Societal interaction on numerous levels is a significant component of Christo's work.

The Kansas City Parks Department has a history of openmindedness toward the support of temporary sculpture projects in areas under its jurisdiction. Notably, there is an on-going program in conjunction with the Sculpture Department of the Kansas City Art Institute whereby student works may be temporarily sited on boulevards in the city. This has been controversial in the eyes of the public and it is a courageous position for the Department to take. Thus, a basis of support existed within the community from which to work to obtain the necessary permission to undertake the project.

After his preliminary visit to Kansas City in late October, 1977, Christo set about to prepare a proposal for the park. In January the proposal was first presented to the Park Director and his three-man commission. The response was reserved but not negative. More specific information was desired. In February a second meeting was scheduled to discuss further the details of the project. One of the major concerns of those inclined to oppose it was the safety of using the wrapped footpaths for the normal activities of walking and jogging. A certain amount of negative feeling had surfaced in letters to the editor of the local paper in the interim between the two

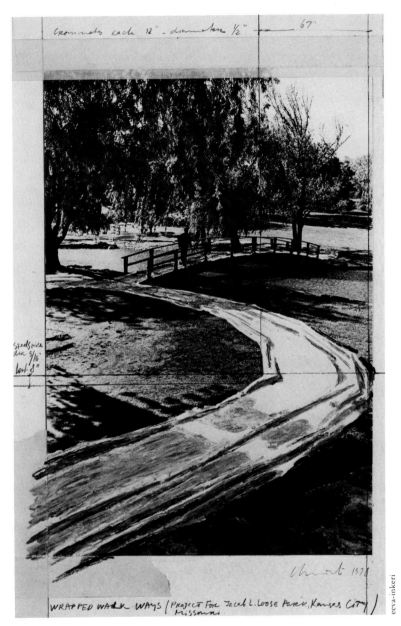

Wrapped Walk Ways (Project for Loose Park, Kansas City, Missouri), 1978. Enamel paint, pencil, and ballpoint pen on photograph. 15 x 9½". Private collection, Kansas City, Missouri

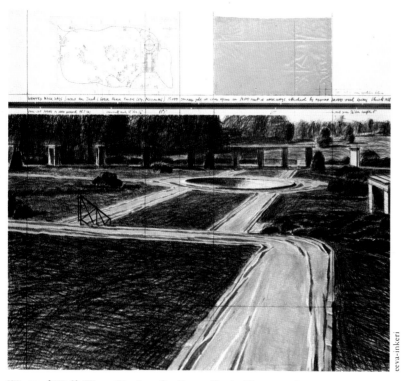

Wrapped Walk Ways (Project for Loose Park, Kansas City, Missouri), 1978. Drawing in 2 parts: pencil, charcoal, pastel, map, and fabric. 15 x 65″ and 42 x 65″. Collection Nelson Gallery–Atkins Museum, Kansas City, Missouri

eeva-inkeri

meetings. These concerns were addressed with attempts to inform the community and particularly the residents of the surrounding neighborhoods of the details of the intended project.

It was decided at the February meeting that a test length of the fabric should be installed so that the commissioners might see for themselves that the fabric would not be dangerous to park patrons. The most numerous users of the park are joggers who throng there daily by the hundreds to run its winding, gently sloping paths. The test was set for mid-April when approximately 100 feet of the fabric, dyed a golden yellow color, was installed on the walk parallel to and behind the pavilion in the northeast portion of the park.

Unfortunately, the first collage which was shown to the park commissioners had depicted the fabric falling in horizontal folds across the walks, reinforcing the skeptics' fear that walkers and joggers might be tripped. The test installation readily cleared up several questions and false suppositions. The folds were longitudinal. The fabric was loose and exquisite; it was not unduly slippery. It could be jogged and walked upon without mishap. It was evident from even so small a piece of an uninspired yellow color fabric that the total effect of the project would be luminous and pleasurable.

Sixty-seven yellow-shirted crew members directed by thirteen construction workers undertook the three-day task of installing 136,268 square feet of saffron-colored nylon fabric, covering 104,836 square feet of paths. The fabric was held in place by 34,500 seven-inch steel spikes hammered through a like number of grommets and by an additional 60,000 staples. Three portable industrial sewing machines and three professional seamstresses along with a crew of helpers stitched 52,394 feet of hems and seams using 250,000 feet of thread. Careful hand stitching of joins, gussets, and folds were done by an additional number of workers. A constant clean-up crew was engaged to keep things tidy. A security force was hired to ensure the integrity of the project and to assure the neighbors that all would be quiet in the environs in the evenings.

Christo's temporary monuments are not traditional works of art in the accepted sense of the general nineteenth-century understanding of that term. Yet, in the final analysis, the same kinds of aesthetic decisions are made by Christo in his conception and realization of a work. The traditional elemental components of line, shape, form, and color, among others, are all employed as they have been throughout history. The immediacy of nature has been added to these elements: coastal hills, mountain valleys, the protean beauty of autumn. His iconography is not rich, and other media of our time, such as film, literature, photography and poetry, tell stories more effectively. His overriding interest lies with perception, a universal concern of artists, and with social process which is so much a part of our democratized view of life.

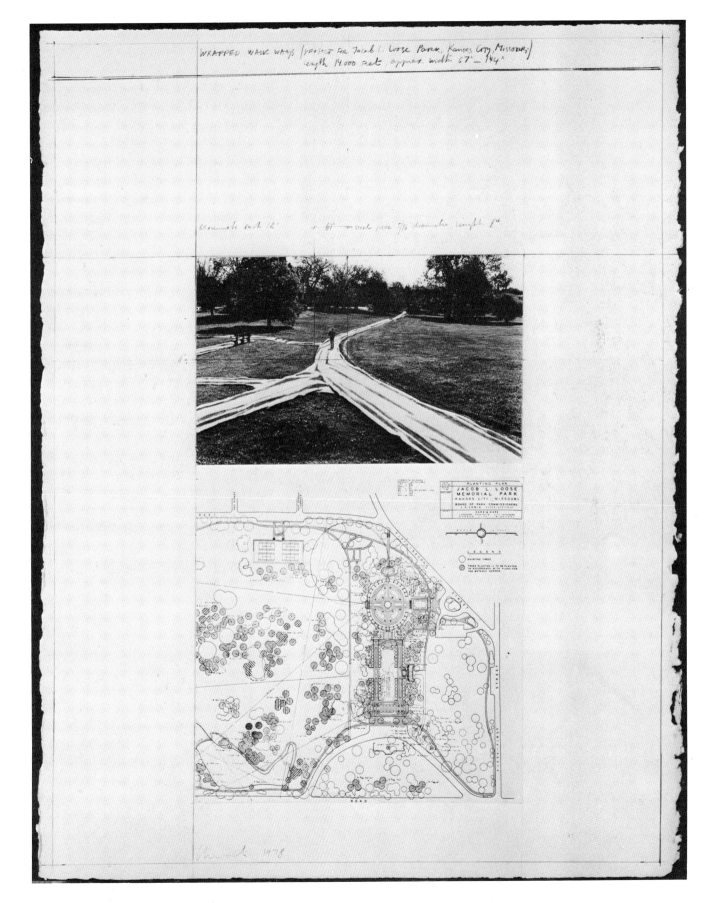

Wrapped Walk Ways (Project for Loose Park, Kansas City, Missouri), 1978. Enamel paint, crayon, pencil, map, ballpoint pen on photograph, 30 × 23¼".

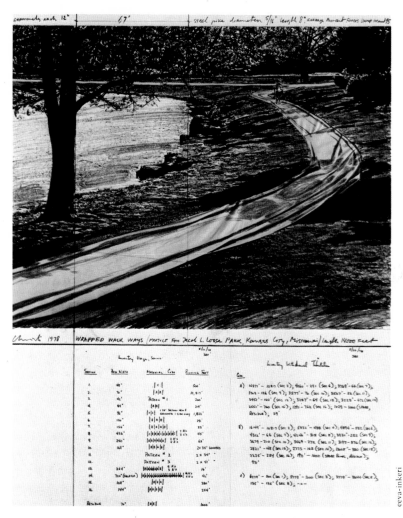

Wrapped Walk Ways (Project for Loose Park, Kansas City, Missouri), 1978. Collage: fabric, photostat, pencil, and technical data. 28 x 22″. Private collection, Essen, West Germany

The Loose Park project seems quite different in character from other of Christo's major works. It is the most public and yet most intimate project he has done to date. It is public in the sense that it is on public land, effortlessly accessible to anyone. Its installation occurred directly in the midst of curious, ubiquitous onlookers: dog walkers, joggers, sidewalk superintendents, dogs without walkers, skeptics, proponents, opponents, school children, reporters, and photographers. *Wrapped Walk Ways* is supremely romantic in feeling. The *Running Fence* and the *Valley Curtain* were titans of dramatic effect. This project is at once bucolic and elegant, with ever so slight a tone of grandness and luxuriousness of the eighteenth century about it, particularly in the rose garden, where the great concentration of fabric seems to bring the scale of the park down to the size of a living room carpet. Even the perimeter walks tend to enclose and specify the extent of the park.

The walk ways of Loose Park were metamorphosed into a fantasy which caused strangers to discourse upon the reasonableness or unreasonableness of covering walks with fabric, inspired the citizenry to analyze what art meant to them and should mean to others, and brought together a disparate group of unquestioningly devoted workers who created a delight for the eye.

Ellen R. Goheen
Curator of Twentieth Century Art
Nelson Gallery–Atkins Museum
Kansas City, Missouri

Wrapped Walk Ways (Project for Loose Park, Kansas City, Missouri), 1978. Enamel paint, crayon, pencil, ballpoint pen on photograph, 15 × 9½″. Collection Jeanne-Claude Christo

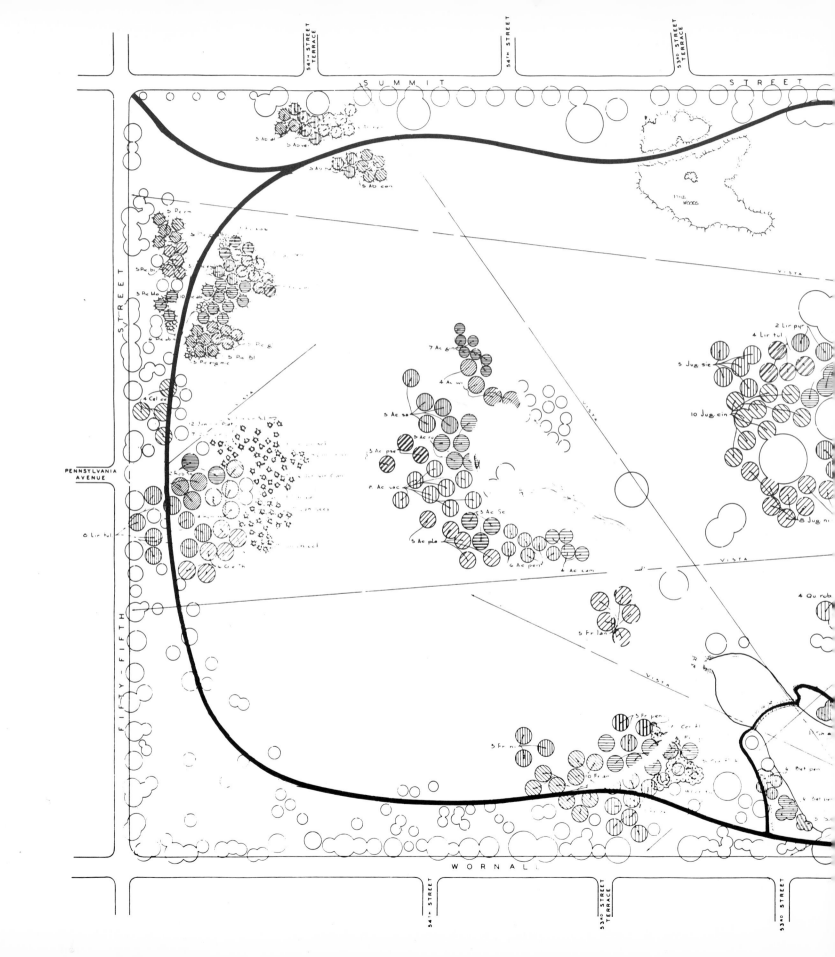

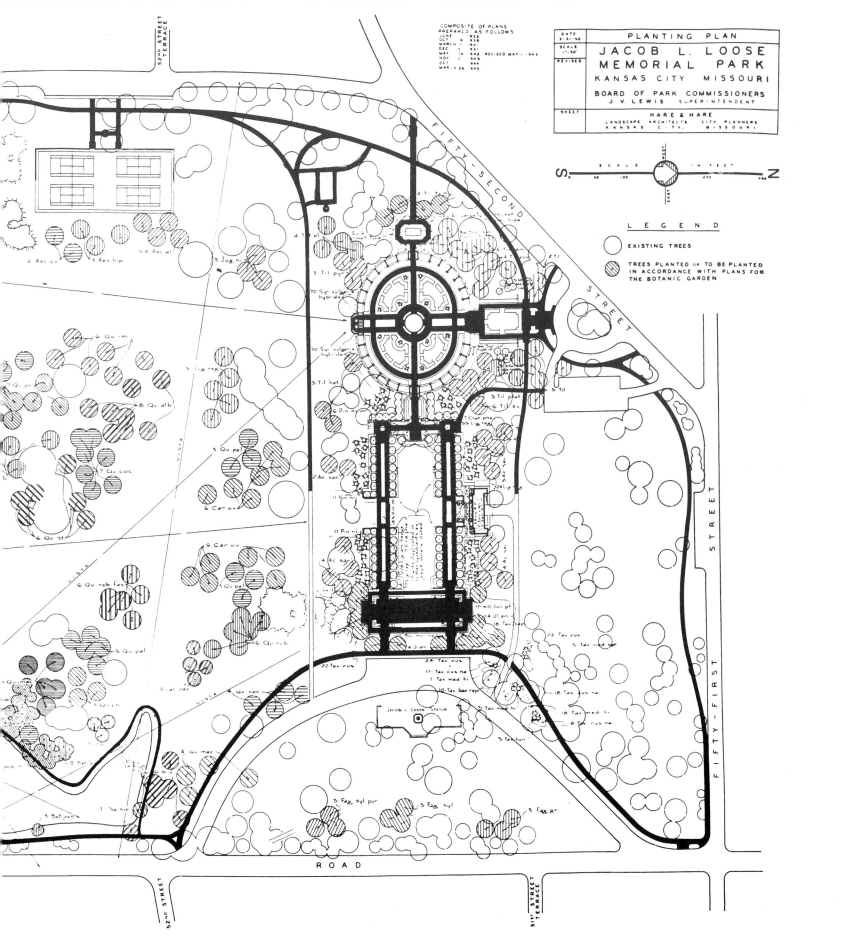

PLANTING PLAN
JACOB L. LOOSE
MEMORIAL PARK
KANSAS CITY MISSOURI
BOARD OF PARK COMMISSIONERS
J. V. LEWIS SUPERINTENDENT

HARE & HARE
LANDSCAPE ARCHITECTS CITY PLANNERS
KANSAS CITY, MISSOURI

COMPOSITE OF PLANS
PREPARED AS FOLLOWS

LEGEND

EXISTING TREES

TREES PLANTED or TO BE PLANTED
IN ACCORDANCE WITH PLANS FOR
THE BOTANIC GARDEN

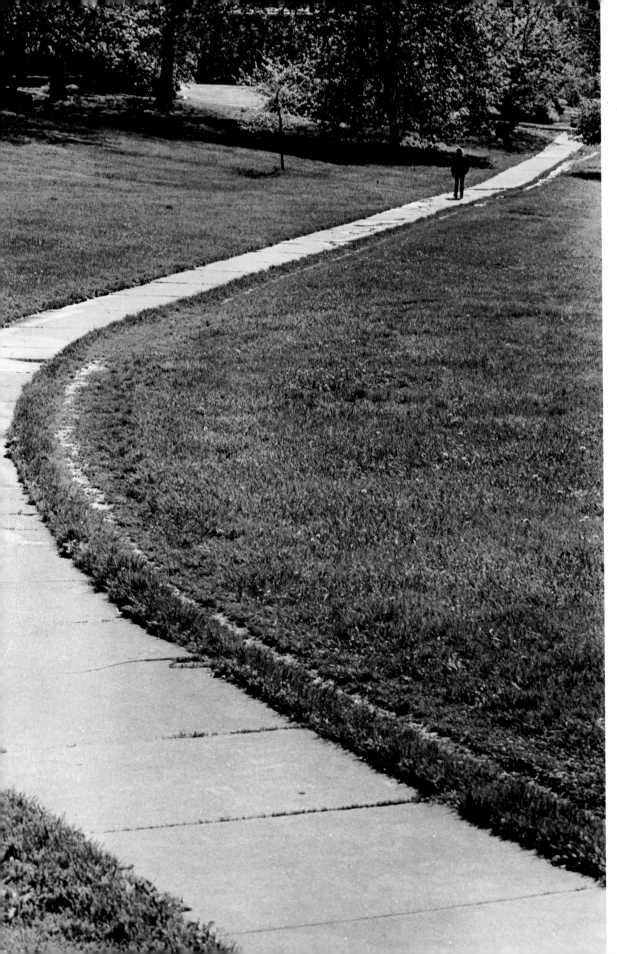

One of the meandering paths in the open, informal setting of most of Loose Park.

The northern segment of Loose Park has
paths and plantings organized in a formal
French manner.

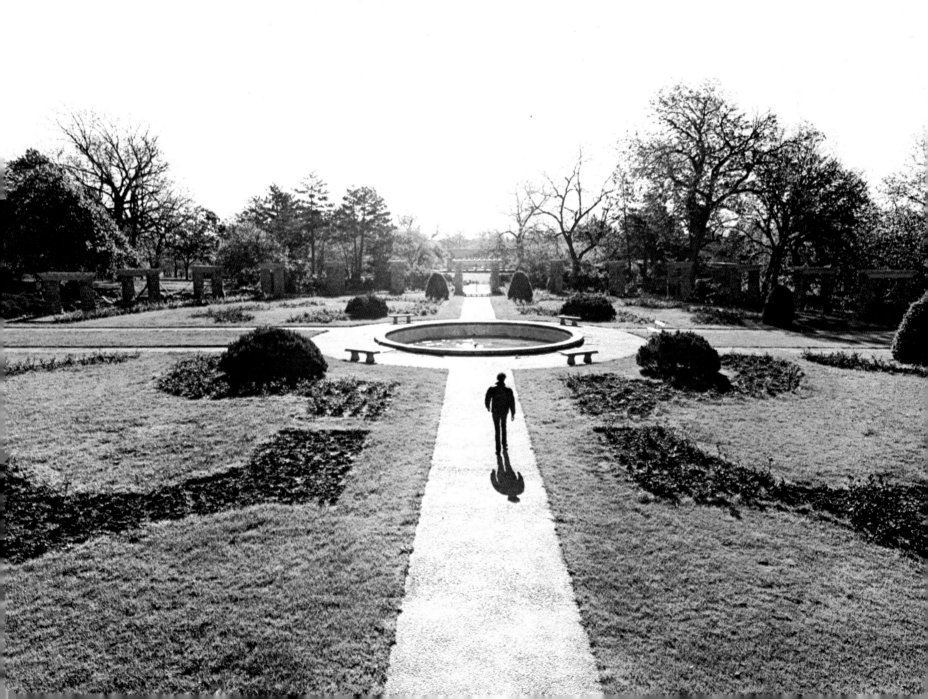

WILLIAM ROCKHILL NELSON GALLERY OF ART
The William Rockhill Nelson Trust
ATKINS MUSEUM OF FINE ARTS
4525 OAK STREET
KANSAS CITY, MISSOURI 64111
(816) 561-4000

7th November 1977

Christo
48 Howard Street
New York, New York 10013

Dear Christo:

Please forgive the delay in forwarding the Loose Park
plans. We had an initial scare. The Loose Trust forbids all
sorts of things taking place in this park, the siting of the
city's new Henry Moore for example. Your proposal, however,
comes under the category of a "temporary" event, so there
appears to be no problem.

You will note on the plan a scheme of walks which have
been inked out. They were never completed. You will also note
the gravel paths around the lake in pencil. The plan has not
been revised since that work was done some years ago.

The initial fund raising gathering was quite successful
and there are plans for another in a few weeks. The Contemporary
Art Society seems, thus, to be moving right along.

If there is anything further that you will need, please
do not hesitate to call.

With kind regards,

Sincerely yours,

Ellen R. Goheen
Curator of Twentieth Century Art

Nov. 21 - Sent card + copy Fuller -
I said I need her OK for expenses.
+ sent copy to Myra Megan

WILLIAM ROCKHILL NELSON GALLERY OF ART
The William Rockhill Nelson Trust
ATKINS MUSEUM OF FINE ARTS
4525 OAK STREET
KANSAS CITY, MISSOURI 64111
(816) 561-4000

23rd September 1977

Oct 29 -
ARR Kansas City 9,40 AM
Braniff # 51

Leave Kansas City. 4,50 p.m. TWA 406
to Chicago +

Christo
48 Howard Street
New York, New York 10013

Dear Christo:

We look forward very much to your visit to Kansas City
on October 29. The formation of the Contemporary Art Society
is a very hopeful portent of enterprising things to come for
the visual arts in Kansas City. It is our hope to initiate
its existence with an exciting, community-oriented project and
we are delighted you will come and have a look.

Would you prefer to have the Society send an air ticket
or reimburse you for one? We also need to know the exact dates
you plan to be in Kansas City so that we might make arrangements
for your accommodation. The recent flood has put one of our
major hotels out of commission for the next couple of months,
so the sooner we can make arrangements the better.

I look forward to hearing from you and to seeing you on the
twenty-ninth.

Sincerely yours,

Ellen R. Goheen
Curator of Twentieth Century Art

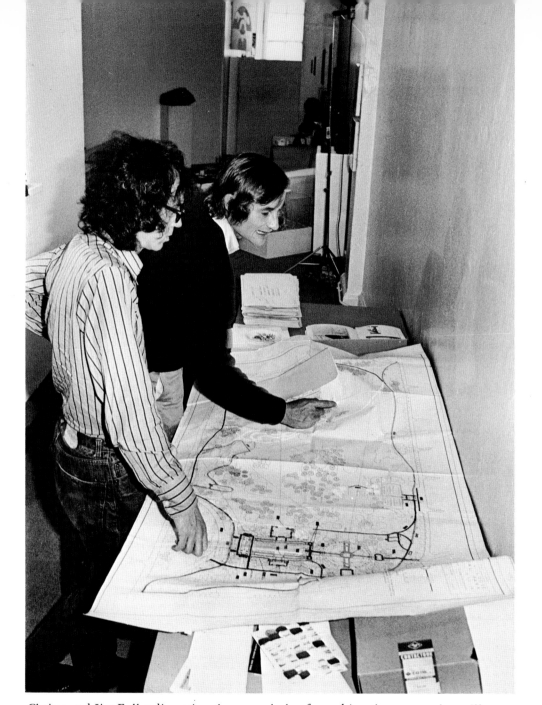

Christo and Jim Fuller discussing the general plan for making the pattern that will be followed for sewing the fabric. Jim Fuller worked with Christo on *Ocean Front/ Newport, Rhode Island,* and *Running Fence.*

TWENTIETH CENTURY LIMITED
271 Western Avenue, Lynn, Massachusetts 01904 (617)581-3208

November 18, 1977

Jeanne Claude Christo
48 Howard Street
New York, New York., 10013.

Dear Jeanne Claude,

 I have received the map of the Kansas City Park which I return herewith. I have marked the pathways as red which appear to be the likely ones to cover. If I have omitted any, or included any which should be excluded, please mark them off or add them to the map so that we have a mutual understanding of the job.

 I would estimate that 60 hours would be required to perform the following tasks which would provide a basis for the cost of the project.

(1) Rough measurements of fabric required.
(2) Availability of various fabrics and costs thereof.
(3) Approximate costs of sewing based on quantities and a preliminary sewing scheme and pattern.
(4) A stress analysis of various anchoring techniques, a recommendation of one, and an approximate cost for the system.
(5) A distribution method for installing the fabric together with manpower and equipment requirements and costs.
(6) A removal system including manpower and equipment costs.
(7) A total budget including engineering and supervision which will be accurate within 15%.

The following items would not be included in the budget to be provided:

(1) Security services.
(2) Bonding or insurance requirements.
(3) Cost of accurate survey of the area if one is not available.
(4) Any building permits or other requirements of law should they be necessary.

 The cost of the job report as outlined above would be $2,400. Please feel free to contact me if you have any questions.

Very truly yours,

James R. Fuller

Enclosure - Map

JRF:wdu

CHRISTO PARK PATH COVER; SPECIFICATIONS

1. MATERIAL: J.P. STEVENS DUPONT #66 NYLON
 20x20 WEAVE, 5.5 OZ
 ODD LOTS: STYLE NO 34139
 34142
 34268
 34303

2. SEAMS: ONE INCH OVERLAP, LOCK STITCH WITH NYLON THREAD (COLOR AS CLOSE TO MATERIAL AS POSSIBLE)

3. SIDES: TRIPLE FOLD HEM 1"+ WIDE; ALSO HEMMED AS INDICATED ON PATTERNS. HEM WIDTH MAY BE INCREASED IF MORE CONVENIENT FOR GROMMETING, BUT NOT TO EXCEED 2"

4. GROMMETS: NO 3 STANDARD (PER SAMPLE) 1" OVERALL, INNER DIA 7/16". GROMMETS PLACED ON 12" CENTERS AT HEM CENTER LEAVING NO LESS THAN 1/4" BETWEEN EDGE OF HEM & EDGE OF GROMMET

5. FINISHED GOODS TO BE PACKAGED ROLLED, LONG SECTIONS (ESP SEC 2) SHOULD BE APPROX 200 yds LONG PER PEICE.

13428' @ 68" 3,125,000 75,198 1/24
 2.4%

			66'		125%
Sec 1		1582' ✓	68"		
Sec 2		3071' ✓	68" (73")		
Sec 3		1201' ✓	62"		
Sec 4		322 ✓	68"	?	
Sec 5		281 ✓	68'	+	
Sec 6		357 ✓	68"		
Sec 7		155 ✓	68		
Sec 8		1051 ✓	68'		
Sec 9		300	120"	–	150"
		450	96"	–	120"
		961 ✓	68"	–	
Sec 10		56'	164"		205"
Sec 11		Special Pattern 75'x200'			3000"
Sec 12	(2)	581' ✓✓	68"		
		270' ✓	68"		
Sec 13		144'	111"	?	139'
Sec 14		314 ✓	70"	?	
Sec 15		680' ✓ outer ring	68"		
		712' ✓ shown x-fed	68"		
Sec 16		326' ✓	68"	–	
Sec 17		Pattern (215')			
Sec 18		212' ✓	68"	?	
Sec 19		198' ✓	68"		
Sec 20		176' ✓ check w/Christo, he doesn't 68"	show	?	
Sec 21		123' ✓	68"		
Sec 22		274 ✓	68"	?	
Sec 23		332' Special	96"	?	120"
Sec 24	(?)	25'x25'		?	375"
		10' square out			

① 68" – 73" 13,428' or 4476 yds
 allow 2" for hem
 allow 18' (approx 25%) for folds
 68" standard width exactly
 88" standard width total

 62" Dyer 50± 68"
 goods 50±

 84" overall width

22' = 20" + 64" = 66"
 1" 1" 1" sew seam

(NB) Finished, dyed goods must be 66" in order to get 84" overall width (riping one third extra panel into 3 22" strips.

hence material quantity equals $\frac{4}{3}$ × 4476 yds

or 5968 yds; say (6000) yds material

(9000 yds hemming
4500 yds seaming)

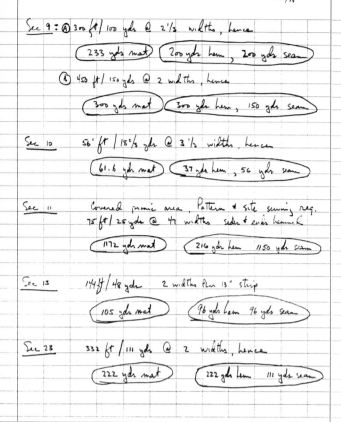

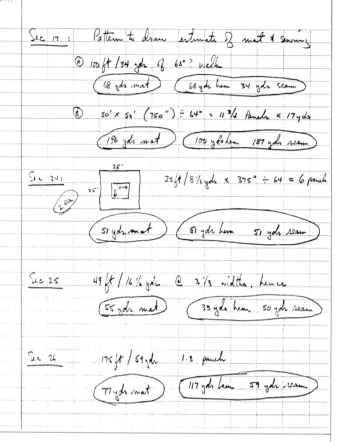

A&H BUILDERS, INC.

March 23, 1978

Christos
48 Howard Street
New York, New York 10013

RE: Wrapped Walkways
Loose Memorial Park
Kansas City

Dear Christos:

Nice to have talked with Jeanne-Claude today for a few minutes. Thank you for the invite to the Christo dinner and program in Kansas City on Tuesday, April 11th. That and the sample Wrapping Wednesday, April 12th will work out well with my giving the Running Fence program at KSU, Manhattan, Kansas, on Thursday, April 13, 1978.

Here are a few notes re: Wrapped Walk Ways, some of which we mentioned on the phone:

1. Display period: probably 1 to 2 weeks;
2. Permits required: from Park Commissioners only;
3. Insurances: Christos will catch probably through St. Paul Insurance Companies.
4. At the sample Wrapping April 12th you will be determining the extra widths (and extra lengths) required to cover both anchorages and fullness for desired appearance;
5. It will be wise to catch then:
 a. accurate measurements of entire project (see item 14);
 b. location and extent of existing damaged areas;
 c. type of temporary (or permanent?) repairs that will be required at those existing damaged areas to avoid danger to the publics walking across those damaged areas which would be concealed by the Wrapping;

Christos
Page 2
March 23, 1978

 d. Permissions or permits required to make such temporary (or permanent) repairs;
6. Wrapping teams to be recruited from either local art students or maybe Senior Scout troop;
7. Storage of materials: at nearby local school;
8. Delivery of materials for installation: via trucks on adjacent streets to Wrapping Teams at perimeter walkways -- the Teams to carry the materials into place or if that not feasible, perhaps use some small "Cushman" type tractor--trailer units;
9. Walkway preparation: repair existing damaged areas that might be danger points when concealed by the Wrapping;
10. Installation:
 a. Broom-clean walkways;
 b. Deliver and roll-out fabric;
 c. Adjust fabric for fullness desired;
 d. Anchor fabric;
 e. Secure free ends at laps?;
11. How to handle fabric at laps to keep people from catching a foot under the free end of the fabric? -- sew it down? -- or secure with double-faced adhesive tape?
12. Will protection from vandalism and repair or replacement of fabric during the display period be necessary?
13. Removals:
 a. Remove steel pins/backfill holes?;
 b. Roll up fabric;
 c. Haul fabric and pins to streets;
 d. Load and deliver fabric and pins to ___?___ ;
14. My take-off shows approximately:
 a. 15,600 LF of walkways X say 6' average = 93,600 SF;
 b. 3 plaza areas: | | SF |

		SF
(1.)	40'x30'	1,200
(2.)	50'x20'	1,000
(3.)	200'x70'	14,000

Total length approx 15,900 LF
Total area approx ?? 109,800 SF

BUILDERS, INC.

Christos
Page 3
March 23, 1978

These length figures are only approximate
from scaling the landscape drawing
(scale: 1"=200') and the area figures are
based on the major assumption of 6' average
width for the 15,600 LF of walkways.
However, those approximate figures are
twice the length and 1½ times the area of
the figures noted in Christo's 1977 memo.
I will have someone recheck my figures and
I will appreciate your rechecking your
figures.

Very truly yours,

A & H BUILDERS, INC.

T. L. Dougherty
President

TLD:nb
Enclosure

Looking forward to seeing you in Kansas City --

BUILDERS, INC.

April 21, 1978

Christos RE: Wrapped Walkways
48 Howard Street Jacob L. Loose Memorial Park
New York, New York 10013 Kansas City, Missouri

Gentlemen:

The Wrapped Walkways is proposed by the artist, Christo, and sponsored
by the Contemporary Art Society of Kansas City, as a temporary two-week art
project scheduled for early October, 1978. Christo proposes to cover the
park's walkways and the open pavilion decking with nylon fabric of a yellow
beige color. The surfaces to be covered include concrete, blacktop, flag-
stone, rock-faced limestone, plain gravel surfacing, and a small amount of
brick and wood pavers, and possibly a grass area at the rose garden. The
various steps will also be included.

Attached is a copy of the lay-out of the park with the proposed areas
to be covered highlighted in yellow. The approximate total lengths and
areas are 16,000 LF and 110,000 SF respectively. These figures can be
firmed up on completion of the field measurements.

The fabric will be furnished cut and sewn in the proper widths and
lengths to suit the varying conditions. The perimeter edges will be
grommetted at 12" O.C. to receive 10" x 3/8" diameter spikes for anchoring
to the earth at those edges. Interior lateral and longitudinal seams,
other than those which can be sewn in the shop, will be field sewn to allow
the total project to be covered with a fully continuous fabric.

Anchorage adjacent to vertical surfaces such as at the base of stair
risers or around the columns at the pavilion will be accomplished by pro-
viding wood furring strips secured in place with the fabric stapled to those
furring strips.

It will be Christo's responsibility to provide the local permissions,
insurances and the fabric fabricated to the proper lengths and widths. He
proposes to use local people, both art students and others who would be

BUILDERS, INC.

Page 2
April 21, 1978

interested in working on the project, to install, monitor and later remove
the fabric and anchorages. He also proposes to give the fabric to the
Parks Department on removal for their use as they wish.

The Wrapped Walkways will be in place for a period of time covering
two weekends during which time the public will be allowed full access and
use of the walkways for their normal pursuits such as walking, strolling,
jogging, etc. A portion of the installation crew will be continued as monitors
during this usage period to answer questions and perhaps to distribute samples
of the fabric, thus encouraging the public's constructive use of and partici-
pation in the project.

It will probably be necessary to engage a local security service to
patrol the area, especially at night, to minimize the possibility of
vandalism.

The contractor's responsibility will be to coordinate and supervise all
of the items of work and to train the crews. Those workers will go directly
on the contractor's payroll. He would also obtain whatever permits might be
required, check, approve and pay the vendor's bills and provide workmens
compensation insurance.

The scope of the work will be to:

 Assist in the field measurements for the fabric;
 Check and recommend methods for special anchorages;
 Receive and store the fabric;
 Assist the Contemporary Art Society in the re-
 cruiting of the installation--monitor crew;
 Train the installation--monitor crew and team
 captains;
 Establish a field office (hopefully in one of the
 existing park buildings);
 Arrange for telephone service for the field office;
 Arrange for temporary drinking water and sanitary
 services for the installation crew;
 Consider, advise and arrange for communications
 systems to the installation--monitor crew
 captains (Walkie--talkies?);
 Furnish materials and equipment for standard
 anchorages (10"x3/8" diameter spikes/spike
 hammers);

BUILDERS, INC.

Page 3
April 21, 1978

 Furnish materials and equipment for special
 anchorages (wood furring strips, anchoring
 devices or adhesives, staplers, etc.);
 Furnish portable sewing machines with portable
 generators on dollies for field sewing;
 Furnish equipment for supervisors easy and speedy
 access to the total area (?electric golf carts?
 --Cushman scooters?);
 Deliver materials from storage to job site;
 Broom-clean the walkways just prior to installa-
 tion of the fabric;
 Supervise the installation;
 Supervise the monitoring;
 Supervise the patrolling;
 Supervise the removals and delivery of fabric
 to the Parks Department;
 Dispose of the other materials for credit as
 feasible;
 Clean-up the area;
 Assist in estimating this portion of the work.

Inasmuch as this work is not of the standard type of construction, it
will be more equitable to all parties for payment to be handled on a "cost
plus fixed fee" basis. AIA standard form no. Alll will be used. (A copy
of this form is attached for your checking, etc. The final adjustments and
negotiations are to handled with Christo.) The cost items are to include
those listed on that form plus the actual job supervision time by a principal
@ $_____/hour. (This will remove the guess work from that item and will
allow a more realistic "fixed fee" quote.)

Financial arrangements will handled directly with the Christos. A
$10,000.00 retainer will be paid in early September, 1978.

Please consider the above information and advise us the amount of the
principal's hourly rate for his job supervision time and the amount of the
"fixed fee" you would charge for handling this project, plus any further in-
formation you would suggest be considered.

A&H BUILDERS, INC.

Page 4
April 21, 1978

Thank you.

Very truly yours,

A & H BUILDERS, INC

T. L. Dougherty
President

TLD:nb
Enclosures

cc: Christos
48 Howard St.
New York, N Y 10013

A. L. Huber & Son
4808 Chelsea
Kansas City, Missouri 64130
ATTN: Mr. Angie Huber

J.E. Dunn, Jr. and Associates, Inc.
4520 Madison Avenue
Kansas City, Missouri 64108
ATTN: Mr. Tom Dunn

A&H BUILDERS, INC.

May 2, 1978

Christos
48 Howard Street
New York, New York 10013

Dear Christos:

Attached is original letter from A. L. Huber & Son in response to our request for quote of April 21, 1978. I have made a copy for our records.

Please note in the first paragraph his stating that the patching and repairing of walkways was not included in the scope of work in our 4/21 letter. Byran Cohen advised me that the Parks Department had mentioned at their April 18, 1978 approval meeting that they would care for the filling of the chuckholes. Please check that item when you sign the contract (or agreement, whatever) with the Parks Department and do let me know.

We still have yet to hear from the other contractor, J.E. Dunn Jr. & Associates. I will so advise you when we do and we will then compare the two proposals. However, this proposal looks very good.

Jim Fuller called me later today. I gave him this info and said I would send him copies of all such information. He also said he had talked on the 'phone with Tom Dunn and they had not yet had time to think about our 4/21 letter. So maybe this quote from Huber will be the one to consider.

Very truly yours,

A & H BUILDERS, INC.

T. L. Dougherty
President

TLD:nb
Enclosure

cc: Jim Fuller
51 Cliff Street, Nahant, Massachusetts 01908

3050 Industrial Lane ■ P.O. Box 418 ■ Broomfield, Colorado 80020 ■ Phone (303) 469-1711

4808 chelsea, kansas city, missouri 64130, phone: 921-2700

general contractor

August L. "Gus" Huber, Jr.
August L. "Augie" Huber III
Joseph T. Huber

April 27, 1978

A & H BUILDERS, INC.

MAY 1 1978

Mr. T. L. Dougherty
A & H BUILDERS, INC.
P. O. Box 418
Broomfield, Colorado 80020

Dear Ted:

I received your letter concerning the "Wrapped Walkways" project, and I am very enthused about it. However, there was one item that we had discussed, the patching and repairing of the walkways, which was not on the scope of work you sent to me.

As I told you over the telephone, I have confirmed with the Kansas City, Missouri Building Permit Department that no permit will be required. Also, I have made several discreet inquiries, and at this time, I feel there will be no adverse reaction from the building trade unions, as long as the actual construction type work (e.g. installation of furring strips, etc.) is handled by union people.

Our carpenter general superintendent and I have made several trips to the Park, and have spent considerable time discussing the various conditions around the walks. If we are lucky enough to be chosen to do this work, I feel that we can be of great help to the project.

Our charges for the work involved would be as follows:

Base Wage - As determined by the Christos for non-union employees
 - As determined by contract agreements for union
 employees (including fringe benefits)

Social Security	6.05%
Workman's Compensation	3.76%
Public Liability	2.533%
Federal Unemployment	.7%
State Unemployment	3.6%
Small Tools	4.0%
Office Overhead	10.0%

The total of all the above for the union trades which would be involved in the first portions of the work are as follows:

Laborer $13.76/hr.; Carpenter $16.33/hr.; Carpenter Foreman $17.65/hr.

Page 2 - Mr. T. L. Dougherty
April 27, 1978

The amount we would charge for principals' time is the same as a carpenter foreman, or $17.65/hr. The fee we would expect for this work is $3,000.00.

Ted, I have followed Christo's work closely since he first proposed the "Valley Curtain" project, and have always been fascinated by it. If there is anything further I can do, please let me know.

Very truly yours,

A. L. HUBER & SON, INC.

August L. Huber, III

ALH3:ej

A G R E E M E N T

THIS AGREEMENT between CHRISTO JAVACHEFF ("Christo") and THE CONTEMPORARY ART SOCIETY, a Missouri Not-For-Profit corporation ("CAS"),

WITNESSETH:

WHEREAS, the parties are desirous that Christo create an art project in Kansas City, Missouri, and to that end the parties desire to herein state their agreement with respect thereto,

NOW, THEREFORE, BE IT AGREED BETWEEN THE PARTIES AS FOLLOWS:

1. Subject to obtaining the approval of the various municipal and other regulatory authorities, Christo agrees to create an art project in Loose Park, Kansas City, Missouri, which Christo conceived, to be installed on or about October 5, 1978, such art project to consist of covering the walks at Loose Park with a colored fabric, attached to the ground with necessary grommets.

2. Christo agrees to pay all costs of the project, including, without limitation, materials, labor, and insurance premiums. Christo shall provide, at his cost, sufficient personnel to handle installation, maintenance and security of the project.

3. It is presently contemplated that the project will be in place for approximately two (2) weeks. However, it is recognized that problems may develop which would necessitate that the project be removed early, and it is agreed that if either party deems it necessary or desirable that the project be removed early, both parties will devote their efforts to that end.

4. The parties agree to obtain liability insurance,

-1-

at the cost of Christo, in such amount and insuring such persons and entities, including the parties, as shall meet the approval of the Kansas City Parks and Recreation Department.

5. Christo retains complete artistic rights, including the copyright, in and to the subject project. Notwithstanding, CAS shall prepare a catalog or other publication regarding the project, which catalog or publication is estimated to cost approximately Ten Thousand Dollars ($10,000.00), and CAS shall also have the right to document the project by means of films, photographs, or other like means, all at the cost of CAS; but Christo reserves complete editorial and photographic control with respect to any such publication.

6. At the conclusion of the project, the colored fabric used in the project shall become the property of the Kansas City, Missouri, Park Department, for such use as it chooses, provided that none of the fabric shall be sold, and provided further that a small amount of the fabric shall be reserved for use in an exhibit related to the project. All other materials used in the project shall remain the property of Christo.

7. Christo agrees to loan works of art acceptable to the Nelson Art Gallery, Kansas City, Missouri, for display at the Nelson Art Gallery, beginning on September 28, 1978. Such works of art shall include drawings, collages, photographs and other documentation relating to the said project.

In addition, the Nelson Art Gallery and CAS shall have the right, for a period of eighteen (18) months after the above mentioned works of art have been displayed at the Gallery, to arrange for the showing of such items at other galleries or public institutions, upon such terms and conditions as shall be agreeable to the Gallery, CAS, and Christo (but Christo shall not be entitled to any revenues therefrom nor be responsible for any

-2-

expenses thereof).

8. In the event Christo fails to pay any costs or expenses of the project which he has agreed to pay, or if CAS is asked to pay expenses or feels obliged to pay expenses, such expenses shall first be submitted to Christo for payment. If Christo acknowledges the validity of such expenses but fails to pay them or any part, CAS may pay them and seek reimbursement from Christo. If Christo does not so reimburse CAS within a reasonable time, Christo specifically authorizes CAS to seize such works of art referred to in paragraph 7 hereof, wherever they may be located, and to sell such portion of said works as may be necessary, upon terms as CAS shall decide, to reimburse itself for such expenses so paid by it.

Except as provided in this paragraph, CAS is not authorized to incur any expenses on behalf of Christo.

9. CAS agrees to continue to use its best efforts to obtain the approval and assistance of necessary municipal and regulatory bodies, and to assist Christo in such ways as shall be mutually agreed upon.

10. The rights and obligations of CAS hereunder are not assignable; nor are the obligations binding upon the heirs or estate of Christo.

11. For purposes of this Agreement, notices or other papers to be delivered to the parties may be delivered:

 (a) If to Christo, to:

 Scott Hodes, Esq.
 Arvey, Hodes, Costello & Burman
 180 North LaSalle Street
 Chicago, Illinois 60601

 (b) If to Contemporary Art Society, to:

 Frederick Beihl, Esq.
 Shook, Hardy & Bacon
 20th Floor, Mercantile Bank Tower
 1101 Walnut Street
 Kansas City, Missouri 64106

-3-

12. This Agreement may be signed in two counterparts and said two counterparts taken together shall constitute the entire agreement between the parties hereto.

Christo Javacheff
CHRISTO JAVACHEFF

THE CONTEMPORARY ART SOCIETY

By _Byron C. Shutz - President_

Dated: _May 22_

-4-

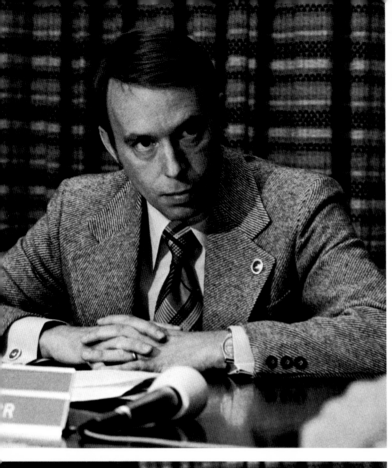

Don White

Don White

Carl Migliazzo (left), Richard Marr (top left), and Jeremiah Cameron (top right), Commissioners of the Kansas City Parks and Recreation Department. ABOVE, left to right: Jerry Darter, Assistant Director; Frank Vaydik, Director; Commissioners Migliazzo and Marr at the public hearings before the Board, April 18, 1978, at which permission for the *Wrapped Walk Ways* project was granted.

AGREEMENT

THIS AGREEMENT, made this _13th_ day of _June_, 1978, by and between KANSAS CITY, MISSOURI, a Municipal Corporation, through its BOARD OF PARKS AND RECREATION COMMISSIONERS, hereinafter called "BOARD," party of the first part, and the CONTEMPORARY ART SOCIETY, Kansas City, Missouri, hereinafter called "SOCIETY," party of the second part

WITNESSETH:

WHEREAS, the BOARD and the SOCIETY desire to provide a contemporary art exhibit, conceived and created by the artist Christo Javacheff ("CHRISTO") in Loose Park, which shall consist of temporarily affixing a nylon fabric material to the paved walkways therein; and

WHEREAS, the SOCIETY represents that it is willing and able to undertake such project

NOW, THEREFORE, in consideration of the mutual covenants and considerations hereinafter contained, the BOARD and the SOCIETY agree as follows:

1. The completed exhibit shall be in place from approximately October 4, 1978 through October 17, 1978 but in no event shall extend beyond a two-week period during the month of October, 1978, without the specific written approval of the BOARD. In addition, Christo shall have approximately ten (10) days prior thereto for the installation of the exhibit and five (5) days thereafter for the dismantling.

2. The BOARD agrees that the SOCIETY and Christo may use all of the walkways in Loose Park in connection with this contemporary art exhibit.

3. The SOCIETY agrees that all materials and labor in connection with this project shall be furnished by Christo and the SOCIETY and that all employees engaged in the construction, maintenance, surveillance or dismantling of this exhibit shall be employees of Christo and not of the BOARD.

4. The SOCIETY agrees that the nylon fabric to be placed on the walks shall be secured by means of round headed steel spikes through grommets provided in the edges of the nylon fabric. All joints shall be sewn securely.

5. The SOCIETY agrees that no vehicles in connection with construction, maintenance, surveillance or dismantling shall be permitted within the boundaries of the Park without the express permission of the representative of the BOARD.

6. The SOCIETY agrees that, on removal of the art exhibit, all public grounds and facilities, including turf, trees, landscaping materials, buildings and walks shall be returned to the condition as they were immediately prior to the commencement of the installation of the exhibit.

7. It is understood and agreed that the BOARD shall have no financial obligation in connection with this project, either in the form of cash outlays, or use of labor of city personnel.

8. The SOCIETY agrees that it, or Christo, shall provide 24-hour per day surveillance of the entire length of the contemporary art exhibit during the entire term of the exhibit.

9. The SOCIETY agrees that in the interest of public safety it, or Christo, shall maintain the contemporary art exhibit in safe condition during the entire term of the exhibit and shall make repairs and adjustments as necessary to insure the safe use of the exhibit.

10. The SOCIETY and Christo shall, at the expense of Christo, procure insurance for the term of the exhibit in a company or companies approved by the BOARD and permitted to do business in the State of Missouri, to protect the parties hereto from claims under the Workmen's Compensation Act; and the SOCIETY and Christo shall procure and maintain, during the life of the exhibit, public liability insurance in the amount of $1. million and property damage insurance in the amount of $50,000; all such insurance to protect both the SOCIETY and the City of Kansas City, Missouri as an additional insured from all claims of any kind and character growing

Jerry Darter (left) and Frank Vaydik at the April 18 meeting.

out of this agreement. Evidence of such insurance, in the form of

certificate(s) showing Kansas City, Missouri as an additional insured,

shall be presented to the BOARD by the SOCIETY at least thirty (30) days

prior to the date of commencement of construction.

11. The SOCIETY agrees to comply with all state and federal laws which may

pertain to this agreement.

12. If the SOCIETY and Christo shall fail or refuse to conform or comply with

any of the obligations or conditions of this agreement, the BOARD may notify

the SOCIETY of such default, and if the SOCIETY and Christo shall remain in

default for twenty-four (24) hours thereafter, the BOARD may thereafter,

upon one day's notice, elect to cancel this agreement and may notify the

SOCIETY of such cancellation, and on receipt by the SOCIETY of such notice

of cancellation, all rights and privileges granted herein shall terminate.

In such event, the SOCIETY agrees that it shall perform all other require-

ments of this agreement related to removal of the exhibit and restoration

of all public properties to their original condition.

13. The SOCIETY agrees that wherever the SOCIETY and/or Christo have an obli-

gation to perform an act hereunder, that, in the event Christo fails to

perform, then the SOCIETY will undertake such performance and the failure

of the SOCIETY to perform shall be considered a default under paragraph 12.

IN WITNESS WHEREOF, the BOARD and the SOCIETY have executed this agreement, all

on the day, month and year first written above.

ATTEST:

BOARD OF PARKS AND RECREATION COMMISSIONERS
KANSAS CITY, MISSOURI

Secretary

President

CONTEMPORARY ART SOCIETY

Title *President*

9233 Ward Parkway, Ste. 145, K.C. Mo. 64114
Address

Mr. Fred Beihl, Shook, Hardy & Bacon
Office for Notice 20th Floor, Mercantile Bk. Twr.
1101 Walnut
K.C. Mo. 64106

APPROVED AS TO FORM & LEGALITY:

Assistant City Counselor

—3—

The Board of Parks and Recreation Commissioners met in regular session.

President Marr in the chair.

Board members present: Marr, Cameron, Migliazzo.

Director Vaydik present.

R. E. Soper, Secretary, present.

On a motion by Commissioner Cameron, duly seconded, the minutes of the meeting of April 11, 1978 were approved.

PARKS AND RECREATION STRUCTURES, GLASS INSTALLATION: On a motion by Commissioner Migliazzo, duly seconded, the following resolution was adopted:

> #19115 - WHEREAS, by Resolution No. 19109, adopted April 11, 1978 taking the bid of Gate City Glass Co. under advisement for the maintenance and revisions of any and all glass installations; and
>
> WHEREAS, said bid contained in Resolution No. 19109 has been carefully analyzed by the staff
>
> NOW, THEREFORE, BE IT RESOLVED THAT the contract be awarded to Gate City Glass Co., the only bidder.

Three Ayes.

PARKS AND RECREATION STRUCTURES, PLUMBING REPAIR: On a motion by Commissioner Cameron, duly seconded, the following resolution was adopted:

> #19116 - WHEREAS, by Resolution No. 19110, adopted April 11, 1978 taking the bids under advisement for plumbing services throughout Parks and Recreation facilities; and
>
> WHEREAS, said bids contained in Resolution No. 19110 have been carefully analyzed by the staff
>
> NOW, THEREFORE, BE IT RESOLVED THAT the contract be awarded to O'Dower Plumbing and Heating Co., the low bidder.

Three Ayes.

CONTEMPORARY ART PROJECT: Pursuant to announcement of the public hearing to be held today relative to the proposed contemporary art project in Loose Park, President Marr asked that those in attendance who opposed this project now be heard. No one arose to speak in opposition to the project. Those in attendance favoring approval of the project expressed their support by acclamation.

On a motion by Commissioner Migliazzo, duly seconded, the Board approved the use of Loose Park as the site of a contemporary art project to be placed there in fall, 1978; subject to the stipulations recorded in the Board's minutes of February 14, 1978 and March 14, 1978.

Three Ayes.

INDIAN CREEK GREENWAY: On a motion by Commissioner Migliazzo, duly seconded, the following resolution was adopted:

> #19117 - WHEREAS, the Board of Parks and Recreation Commissioners has been engaged in acquiring land for Indian Creek Greenway for some years by purchase, gift, and federal aid; and
>
> WHEREAS, Tom E. Beal, as owner of III Fountains Apartments has offered a certain land parcel in and adjacent to Indian Creek on the north side of Indian Creek between Belleview Avenue and Washington Street to be used for park purposes

CONSOLIDATED INVENTORY - SHIPPING

After dyeing, the material should be packaged in a manner chosen by Putnam; the total weight will be 6880 pounds (approx), therefore 14 packages of 500 pounds would be appropriate. However, the goods should be combined to conform to the CODE below, without comingling codes in any single package. There will be some variations (on the order of 5%) from the average width below; this is expected and codes should not be subdivided to accomodate this problem. Each package should be clearly labeled in two places as to the width code and the actual length (feet) of the goods contained therein.

AVERAGE WIDTH	TOTAL LENGTH	CODE
45"	14877 ft.	A
57"	16149	B
64"	6279	C

PATTERN NUMBER 1, SECTION 3

10 200 foot 'C' Panels to be seamed together in the standard fashion; hemmed and grommeted on both sides and both ends to result in a section measuring 200' by 52'. For folding and packaging, the section should be placed finished side up with a tag securely attached to the center grommet on each end. The material should then be rolled from each side toward the center, the roll should then be secured with stout twine about every ten feet along the 200' lenght. (Fig 1)

The roll may now be folded over on itself lengthwise to produce a total 25' length, which should again be secured with twine about every 5'. This bundle should then have a tight cocoon sewn around it and be clearly labeled as Section 3 in several spots. In shipment, the bag should lay flat on the floor of the truck. This will be the heaviest single package (415 lbs) and, therefore, it is important that the cocoon maintain it's shape during shipment in order to facilitate unloading and placement in Kansas City.

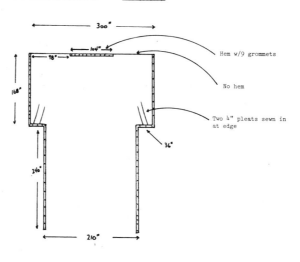

NOT TO SCALE

PATTERN NUMBER 3, SECTION 12 NOT TO SCALE

No hem on one of two pieces

TWO REQUIRED

PATTERN NUMBER 2, SECTION 11 NOT TO SCALE

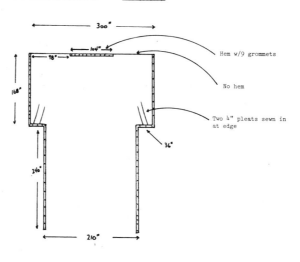

Hem w/9 grommets

No hem

Two 4" pleats sewn in at edge

TWO REQUIRED

Christo, with Robert Urie and Jim Fuller, making the final color choice for the fabric with the manager of the Putnam-Herzl Factory, Putnam, Connecticut.

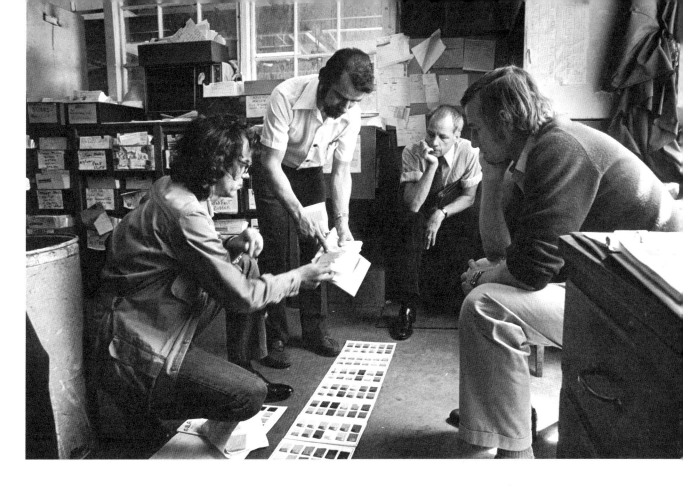

During inventory, a factory worker checks the 15,000 yards of fabric in rolls with widths varying from 44 to 64½ inches.

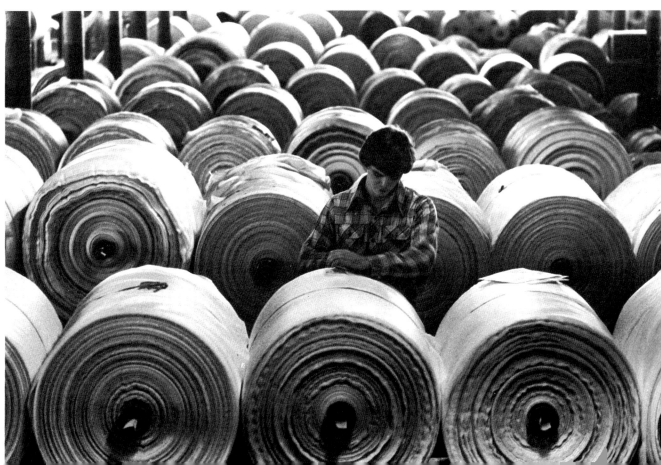

Analysis of and Field Instructions for <u>Sec 16 - Reflecting Pool</u>.

to determine the inner & outer circumferences of the path around the pool:

$C = \pi D$

INNER: $3.14 \times 36' = 113.04'$

OUTER: $3.14 \times (36' + 22.5') = 183.7'$ hence:

$183 \div 113 = 62\%$

OUTER

INNER

3.5" CUTOUT

$1" = 12" \times 62\% = 7.5"$; therefore a 3.5" cutout should be made between each grommet and the seam reattached with staples on a ½" seam to create a 4.5" shorter side $(12" - 7.5" = 4.5")$

Inventory Usage, Sewing

SECTION	PATH WIDTH	MATERIAL CODE	RUNNING FEET												
1.	48"	[C]	500'												
2.	70"	[A	B]	10,817'											
3.	42'	PATTERN #1	200'												
4.	84"	[B	B]	219'											
5.	96"	[C	C] (35' SECTION- HEM & GROMMETS 1 SIDE ONLY)	1,822'											
6.	120"	[B	A	B]	291'										
7.	156"	[B	A	A	B]	33'									
8.	456"	[C	B	B	C	B	B	B	C] 7 B's 3 C's	45'					
9.	240"	[B	B	A	A	B	B] 2 A's 4 B's	63'							
10.	168"	[B	B	A	B]	2 x 35' LENGTHS									
11.		PATTERN #2	2 x 34' "												
12.		PATTERN #3	2 x 41' "												
13.	264"	[B	A	A	A	A	B] 4 A's 3 B's	16'							
14.	720" (FIELD CUT)	[B	B	A	A	A	A	A	A	A	A	A	B	B] 16 A's 4 B's	42'
15.	108"	[A	B	A]	380'										
16.	144"	[A	A	A	B]	254'									
RESIDUE	70"	[A	B]	1000'											

SEWING AND GROMMET QUANTITIES

SECTION	SEAM	HEM	GROMMETS
1	-0-	1000	1000
2	10817	21634	21634
3	1800	500	500
4	219	438	438
5	1822	3609	3609
6	582	582	582
7	99	66	66
8	405	90	90
9	315	126	126
10	210	140	140
11	260	166	167
12	506	208	208
13	96	32	32
14	798	84	-0-
15	760	760	760
16	762	508	508
Residue	1000	2000	2000
TOTALS	20451 Feet	31943 Feet	31860

Inventory Withdrawal Tabulation

Code

A) 14877' - 10817 (SEC 2); 4060' - 291 (SEC 6); 3769' - 66 (SEC 7); 3703 - 126 (SEC 9); 3577' - 70 (SEC 10); 3507' - 56 (SEC 11); 3451' - 164' (SEC 12); 3287' - 64 (SEC 13); 3223' - 672 (SEC 14) 2551' - 760 (SEC 15); 1791 - 762 (SEC 16); 1029 - 1000 (SPARE, RESIDUE); 29'

B) 16149' - 10817 (SEC 2); 5332' - 438 (SEC 4); 4894' - 582 (SEC 6); 4312' - 66 (SEC 7); 4246' - 315 (SEC 8); 3931' - 252 (SEC 9); 3679 - 210 (SEC 10); 3469 - 272 (SEC 11); 3197 - 376 (SEC 12); 2821' - 48 (SEC 13); 2773 - 168 (SEC 14); 2605' - 380 (SEC 15); 2225' - 254 (SEC 16); 1971' - 1000 (SPARE PANEL, RESIDUE); 971'

C) 6279' - 500 (SEC 1); 5779' - 2000 (SEC 3); 3779' - 3644 (SEC 5); 135' - 135' (SEC 8); -0-

The fabric was
pressure dyed at the
Putnam-Herzl Factory.

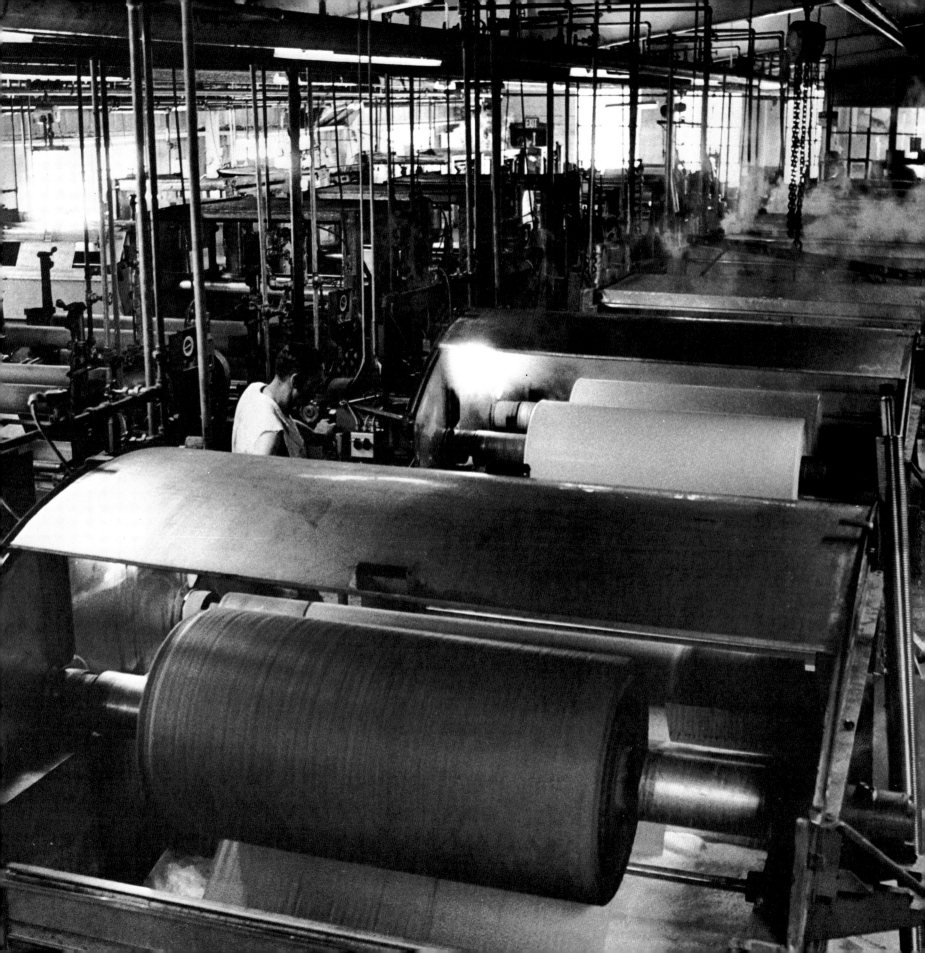

May 23, 1978

Mr. Robert Schnurr
Rubbercrafters, Inc.
P.O. Box 220
Grantsville, West Virginia
26147

Dear Sir;

I enclose herewith some of the necessary details with respect to Christo's project for Loose Park in Kansas City. You will recall that we discussed the sewing requirements over the telephone about a month ago. We expect that the material will arrive in West Virginia at the end of June or during the first week of July. Partial shipments could be made earlier than that if it will facilitate your schedule. We will need to have the material ready to leave your plant in late August, or no later than the first week of September.

The materials enclosed are as follows:

 1. Consolidated inventory of material as shipped to you.
 2. Sewing and grommet quantities
 3. Inventory usage and general patterns
 4. Three special patterns - these are the only three
 5. General sewing and grommeting instructions
 6. Inventory withdrawal tabulation

I hope that this information will be sufficient for you to give us both a cost estimate and an indication of your ability to meet the schedule. I would appreciate an early indication of the above directed to Christo with a copy to me.

Very truly yours,

James R. Fuller
51 Cliff Street
Nahant, Massachusetts 01908

cc: Christo
 48 Howard Street
 New York, New York 10013

J. P. Stevens & Co., Inc.

JP5-40259-2 (9-76)

STEVENS TOWER • 1185 AVENUE OF THE AMERICAS • NEW YORK, N.Y. 10036

FINISHED GOODS CONTRACT

Dunean

DATE	CONTRACT NO.
7/7/78	42688

SOLD TO
The Running Fence Corp
Christo Div.
48 Howard St.
New York, N.Y. 10013

SHIP TO
Route 150
Craigsville, West Virginia

VIA
Truck

CUST. CODE	OFC	S/MAN	CUST. ORDER NO. (For Identification Only)
7762531	65	999	

TERMS: net c b d
NO ANTICIPATION ALLOWED UNTIL 10 DAYS AFTER DATE OF INVOICE
ALL BILLS PAYABLE IN NEW YORK FUNDS BANKABLE AT PAR

PRICE F.O.B. MILL
Putnam, Ct.

STYLE & FABRIC

Asstd as below-finished goods as are no claims no returns

QUANTITY

12,802 yds. Miscellaneous fin. gds.

DELIVERY

see below

ASSORTMENT – MUST BE FURNISHED IN WRITING BY BUYER TO SELLER WITHIN 30 DAYS PRIOR TO DELIVERIES CALLED FOR BY CONTRACT

YARDS	style	PRICE		YARDS	COLOR	PRICE
		$.50000 flat				
	34139/61					
2,463 yds during w/e 7/1/78						
4,957	34142/9					
2,815	34268/4					
2,567	34303/9					

at once

FIRM NAME

BY _____

DATE _____

ACCEPTED BY J. P. STEVENS & CO., INC.

AUTHORIZED SIGNATURE

JUL 17 1978

COPY NO. 1

A&H BUILDERS, INC.

June 5, 1978

Christos
48 Howard Street
New York, New York 10013

RE: Wrapped Walkways
 Loos Memorial Park
 Kansas City, Missouri

Dear Christos:

I previously sent direct to Jim Fuller a copy of my schedule of Comparison of Costs and Average Pull-Out Forces of Various Spikes based on pull-out tests we did here together with one each of the various spikes for his checking the head diameters relative to the grommets he proposes to use. Attached for your records is copy of those schedules. Jim called May 30th saying "the 5/16"x8" spikes look fine to him".

Please check with Jim regarding these comparisons plus any other considerations you may have and select the spikes the two of you decide to use. Then please so advise Augie Huber so he can order them.

Very truly yours,

A & H BUILDERS, INC.

T. L. Dougherty
President

TLD:nb
Enclosure

cc: Jim Fuller

 Augie Huber
 A.L. Huber & Son

3050 Industrial Lane ■ P.O. Box 418 ■ Broomfield, Colorado 80020 ■ Phone (303) 469-1711

June 22, 1978

August L. Huber 111
A. L. Huber and Son
4808 Chelsea Street
Kansas City, Mo. 64130

Dear Augie;

I trust you have now received the executed copy of the contract covering Loose Park. I want to take this opportunity to welcome you to the team. I know that you will enjoy the project and working with the Christos as much as I have over the years.

Ted Dougherty has run a series of tests of various sizes of spikes and I have tentatively approved a spike which measures 5/16ths by 8" as having sufficient holding power for the job. I do have two major concerns about these spikes. First, we must be very careful that the head of the spike does not slip through the grommet. Second, we should test the local soil conditions to insure that they give the same result as in earlier test in Colorado. At some early opportunity, I wish that you would purchase a few spikes locally, and, using the grommeted fabric sample I am enclosing, make sure that the spike will not slip through the grommet. Secondly, construct a test rig consisting of a tripod about 4' high, a hanging scale, and a block and tackle. By arranging these ingredients in an obvious fashion above a spike driven through one of the grommets in the fabric sample provided, you will be able to tell me the force in pounds required pulling directly up to pull the spike free. Several such tests at different locations in the park would be useful.

While you are shopping for the several spikes which you need, you should pin down a price and lead time required for the 32,000 we will need in September. I do not wish to order them now but would hold this variable in reserve against abnormal weather conditions which might require a design change; however it will be useful to know when we must order to have them on hand by September 15th.

I am enclosing design drawings which will give you some feeling for the scale of the operation. Christo and I will plan to come to Kansas City in the latter part of July to discuss some of the installation details.

Very best regards;

James R. Fuller
51 Cliff Street
Nahant, Massachusetts 01908
617 581 1900

cc: Ted Dougherty
 Christos

Rubber Fabricators of West Virginia, Graigsville, West Virginia, sewed the center seams and side hems of the huge quantity of fabric.

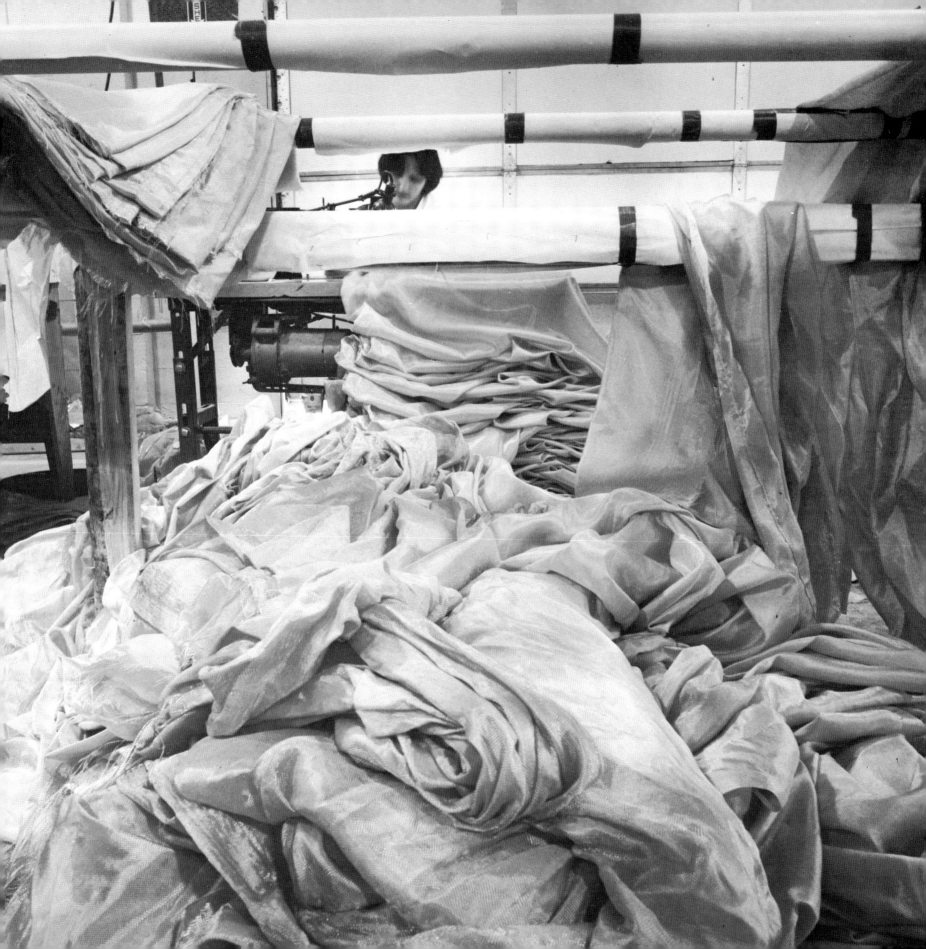

4808 chelsea, kansas city, missouri 64130, phone: 921-2700

general contractor

August L. "Gus" Huber, Jr.
August L. "Augie" Huber III
Joseph T. Huber

June 29, 1978

Mr. James R. Fuller
51 Cliff Street
Nahant, Massachusetts 01908

Dear Jim:

Enclosed is a tabulation of soil pull-out tests that we did at various areas of the Park. As you can see, my findings were considerably different from Ted's. Ours were done with a direct reading tension scale attached to the nail on the lower end and the lever on the top. I wonder if perhaps Ted used a pulley arrangement below the tension scale which would increase the pull-out by one-hundred percent. At any rate, these were the forces we experienced. The dirt was very dry and the moisture content will obviously make a significant difference.

Also, we found that by driving the spikes in at an angle, we had no appreciable increase in the pull-out tension needed, but the tension was consistent for the full length of the nail, rather than decreasing after the initial release of the nail. Additionally, on many of the concrete sidewalks, we noticed a significant decrease when the nail was placed within 6" of the formed edge of the walk. This is probably due to the loose backfill when the walk was originally poured.

Another point which we should consider and try to resolve as soon as possible is the method of attachment at the stairs. Several of the alternates which we have considered require some degree of factory work in addition to the field work. If we decide to use any nylon line, we should be ordering it immediately since, if it is to be exposed, it should probably be dyed to match the fabric.

I have talked with Midwest Embroidery Company, which is a local company in the business of doing comparatively large scale sewing of banners, flags, etc. I am slightly concerned about the quality control if we are hiring people "off the street" for this phase of our work. I told them we would be in contact with them when either you or the Christos were in town.

Continued

Page 2 - Mr. James R. Fuller

I need to get a copy of your large scale drawings so that I might at least have some preliminary cost and scheduling estimates ready when you visit here in mid-July.

If you have any questions, please give me a call.

Very truly yours,

A. L. HUBER & SON, INC.

August L. Huber, III

CC: Ted Dougherty
 Christos

"Wrapped Walkways" Loose Park

Location	1/4" x 10" Nail	3/16 x 8" Nail	
South of Rose Garden Building	65#	25#	
	42#	24#	
	40#		
Walk between Rose Garden & Tennis Court	72#	30#	
	30#	50#	
	50#	40#	
	58#	34#	
	30#	28#	
	64#	80#	(Root?)
	42#	68#	
		42#	
		30#	
12' Walk West of Rose Garden	50#	18#	
	75#	22#	
	60#	30#	
	64#	30#	
		42#	
		20#	
At ⌀ Fountain in Rose Garden		30#	
		50#	
Dirt		24#	
Sand	10#	10#	
	8#	2#	
	8#	10#	
		22#	
		12#	
		10#	
Walk Between Pavillion & Rose Garden (in Bushes)		72#	
		92#	

Location	1/4" x 10" Nail	3/16" x 8" Nail
South Side of Pavillion	22#	10#
	12#	8#
	22#	10#
	6#	14#
	34#	
	70#	
	22#	
	42#	
Gravel Walk - N. Side of Lake (outside of wood edging strip)	12#	22#
	22#	40#
	22#	30#
		44#
Gravel Walk - W. Side of Lake (in AB-3 Base Rock)	40#	36#
	36#	36#
		36#
		80#
Asphalt Walk - N. end of Park		35#
		40#
		50#
		40#
		32#
		52#
		44#
		38#
		40#
		44#
Average	37.7#	34.6#

For *Wrapped Walk Ways* Christo used J.P. Stevens fabric woven of 100 percent nylon yarns, 840 denier, 20 x 20 yarns per inch.

contemporary art society

June 16, 1978

Mr. And Mrs. Christo Java Cheff
48 Howard Street
New York, New York 10013

Dear Jeanne Claude and Christo:

We finally have received a firm offer from the St. Paul Companies for liability and property insurance coverage for the Loose Park project. The premium is $937.00 and the policy is for one million dollars bodily injury and fifty thousand dollars property damage. The period covered by the policy is from September 24, 1978 through October 21, 1978.

A check should be written for the full amount ($937.00) made payable to Conrad and O'Reilly, Traders National Bank Building, 12th Grand Avenue, Kansas City, Missouri 64106. A policy will be furnished to the Contemporary Art Society within the next three weeks with a copy for you, the Parks and Recreation Department and A. L. Huber & Son.

If you have any questions, please give me a call.

Sincerely,

John L. Hoffman

vo

cc:Byron Cohen
 Ellen Goheen
 Fred Beihl

acord — Certificate of Insurance

THIS CERTIFICATE IS ISSUED AS A MATTER OF INFORMATION ONLY AND CONFERS NO RIGHTS UPON THE CERTIFICATE HOLDER. THIS CERTIFICATE DOES NOT AMEND, EXTEND OR ALTER THE COVERAGE AFFORDED BY THE POLICIES BELOW.

NAME AND ADDRESS OF AGENCY
Conrad & O'Reilly, Inc.
1125 Grand Ave., Suite 1200
Kansas City, Missouri 64106

COMPANIES AFFORDING COVERAGES	
COMPANY LETTER A	St. Paul Fire & Marine Ins. Co.
COMPANY LETTER B	
COMPANY LETTER C	
COMPANY LETTER D	
COMPANY LETTER E	

NAME AND ADDRESS OF INSURED
Christo Javacheff
c/o John Hoffman
Ten Main Center
Kansas City, Missouri 64105

This is to certify that policies of insurance listed below have been issued to the insured named above and are in force at this time.

COMPANY LETTER	TYPE OF INSURANCE	POLICY NUMBER	POLICY EXPIRATION DATE	Limits of Liability in Thousands (000)	EACH OCCURRENCE	AGGREGATE
A	**GENERAL LIABILITY** [X] COMPREHENSIVE FORM [X] PREMISES—OPERATIONS [] EXPLOSION AND COLLAPSE HAZARD [] UNDERGROUND HAZARD [] PRODUCTS—COMPLETED OPERATIONS HAZARD [X] CONTRACTUAL INSURANCE [] BROAD FORM PROPERTY DAMAGE [X] INDEPENDENT CONTRACTORS [] PERSONAL INJURY	580JH1686	10-21-78	BODILY INJURY	$ 1,000	$ 1,000
				PROPERTY DAMAGE	$ 50	$ 50
				BODILY INJURY AND PROPERTY DAMAGE COMBINED	$	$
				PERSONAL INJURY		$
	AUTOMOBILE LIABILITY [] COMPREHENSIVE FORM [] OWNED [] HIRED [] NON-OWNED			BODILY INJURY (EACH PERSON)	$	
				BODILY INJURY (EACH OCCURRENCE)	$	
				PROPERTY DAMAGE	$	
				BODILY INJURY AND PROPERTY DAMAGE COMBINED	$	
	EXCESS LIABILITY [] UMBRELLA FORM [] OTHER THAN UMBRELLA FORM			BODILY INJURY AND PROPERTY DAMAGE COMBINED	$	$
	WORKERS' COMPENSATION and EMPLOYERS' LIABILITY			STATUTORY		
					$	(EACH ACCIDENT)
	OTHER					

DESCRIPTION OF OPERATIONS/LOCATIONS/VEHICLES

Cancellation: Should any of the above described policies be cancelled before the expiration date thereof, the issuing company will endeavor to mail 10 days written notice to the below named certificate holder, but failure to mail such notice shall impose no obligation or liability of any kind upon the company.

NAME AND ADDRESS OF CERTIFICATE HOLDER
Christo Javacheff
c/o John Hoffman
Ten Main Center
Kansas City, Missouri 64105

DATE ISSUED 7-14-78

John J. O'Reilly
AUTHORIZED REPRESENTATIVE

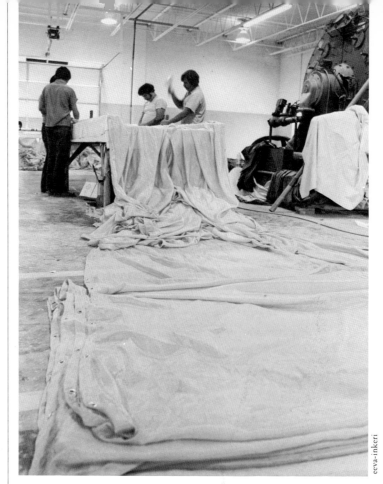

The 34,500 ½-inch-wide brass grommets were installed at 12-inch intervals by Rubber Fabricators of West Virginia.

eeva-inkeri

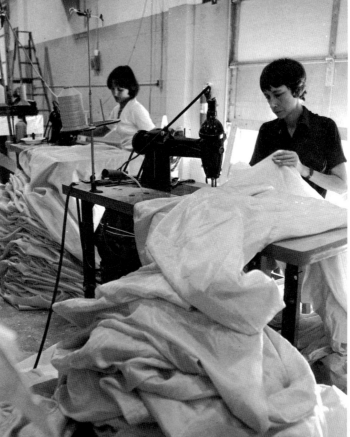

The fabric was sewn following a pattern which took into account the various widths of the paths.

eeva-inkeri

BELOW: Tom Golden, Christo, and Harrison Rivera discussing the possibility of tucking the fabric underneath the shrubbery.

BOTTOM: Tom Golden, who also worked with Christo on *Running Fence,* spent hours coding maps for the crew leaders.

BELOW: Ted Dougherty (left), builder/contractor for *Valley Curtain* and *Running Fence,* flew with Christo to Kansas City in April to find a local contractor for *Wrapped Walk Ways.* He is seen here with August L. "Augie" Huber III, the Kansas City builder, discussing security for the neighborhood around the park. In addition to twenty monitors for the project itself, Christo hired 24 off-duty Kansas City policemen to ensure peace in the neighborhood during the two-week period of the *Wrapped Walk Ways* project.

BOTTOM: Stairways presented special problems of installation. For the safety of the people using the steps, a plywood platform was put in place over which the fabric was later stapled.

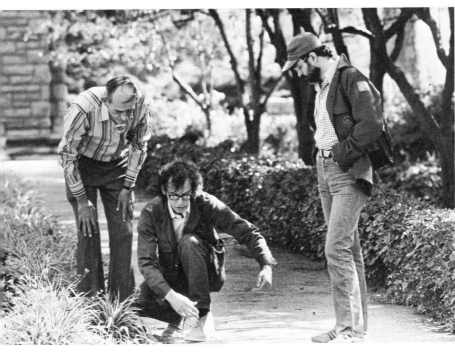

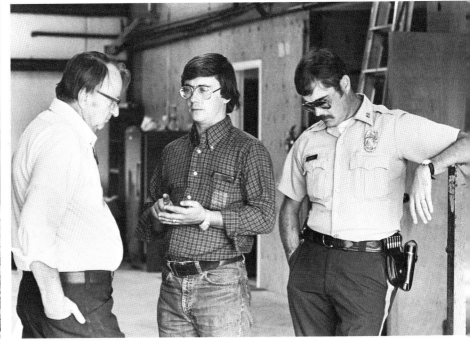

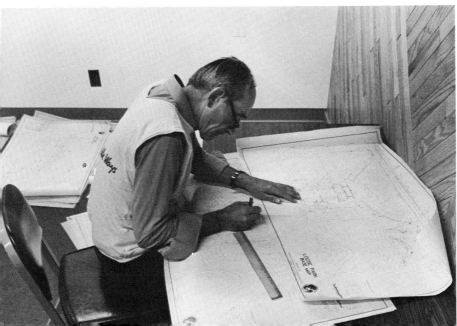

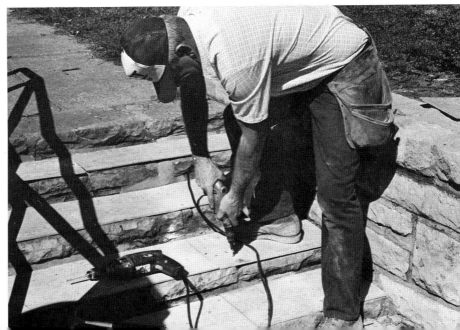

BELOW: On the afternoon of October 1, workers who had applied for jobs as installers and been accepted by Augie Huber signed in for an orientation session (opposite, below). Everybody who worked on the project was paid.

BELOW, RIGHT: A few hours before the arrival of the workers the crew leaders were given their instructions.

OPPOSITE, TOP: Augie Huber, Jim Fuller, Mitko Zagoroff, and Christo ready to answer questions during the orientation session.

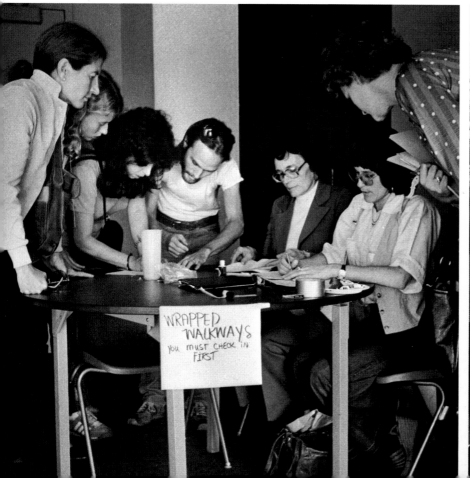

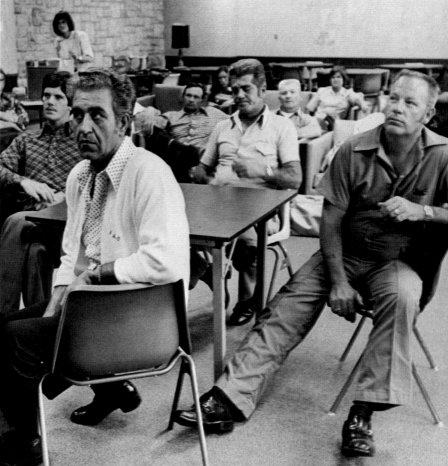

BELOW: At 6:30 A.M. of October 2, Augie Huber (left), Jim Fuller, Mitko and Lizzie Zagoroff made up a check list for the fabric.

BOTTOM: Jane Gregorius, Dan Teleen, and Augie Huber signing in workers for the day.

BELOW: Anselm Spoerri from Switzerland, the youngest worker, helped unload the fabric. The fabric with code numbers on each bundle arrived from West Virginia in a rented truck.

BOTTOM: Augie Huber leads the first team of workers to the southwest intersection of the park to begin installation (opposite).

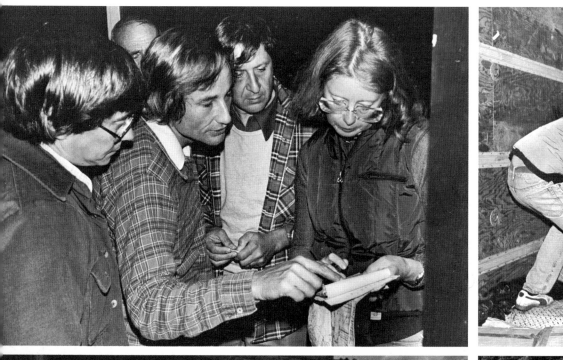

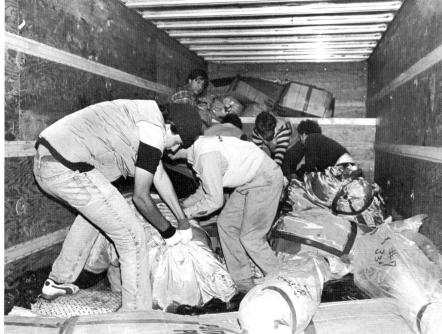

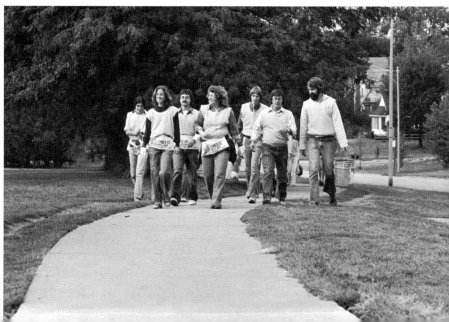

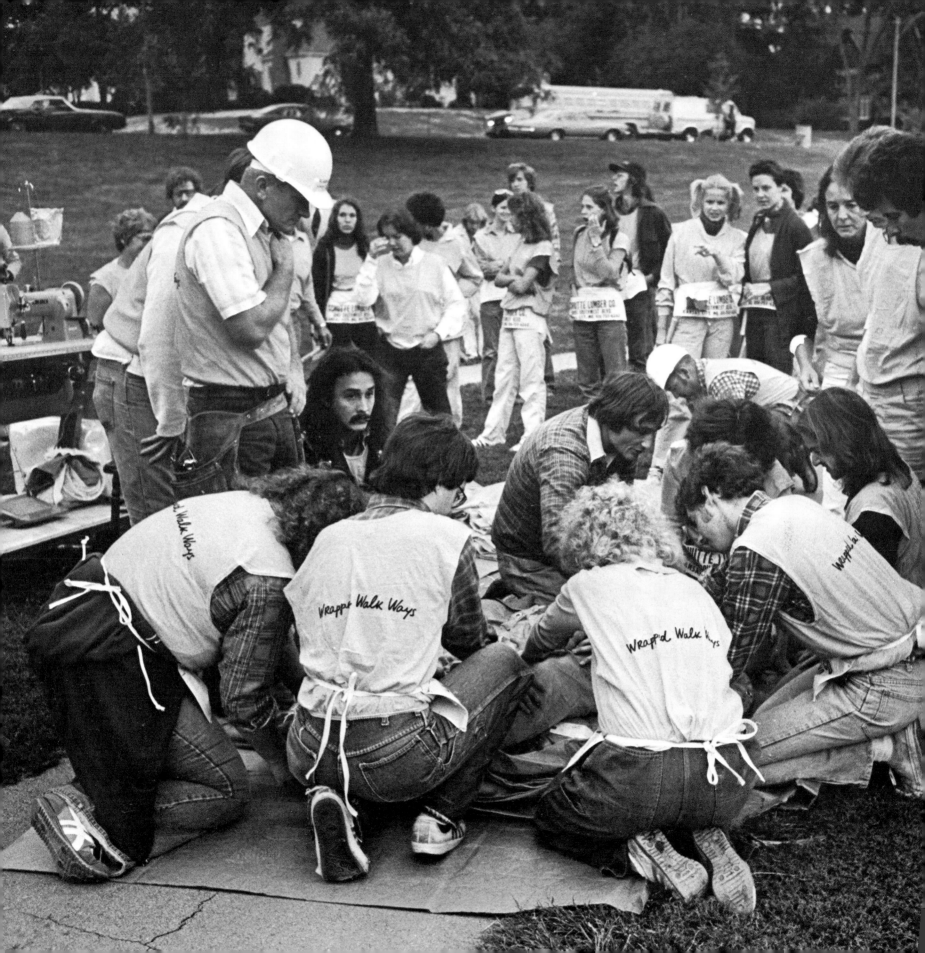

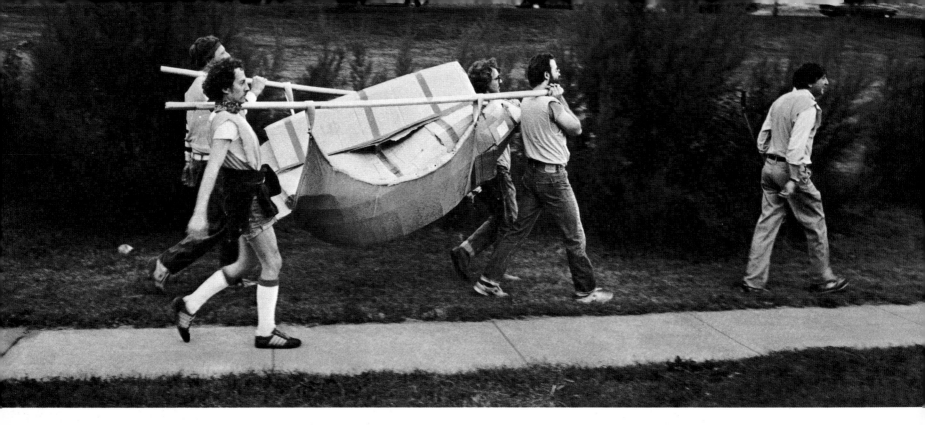

ABOVE: Jim Fuller, led by Mitko, uses his "coolie system" to deliver the fabric to the installation sites.

RIGHT: At top left is one of the four golf carts used to deliver supplies.

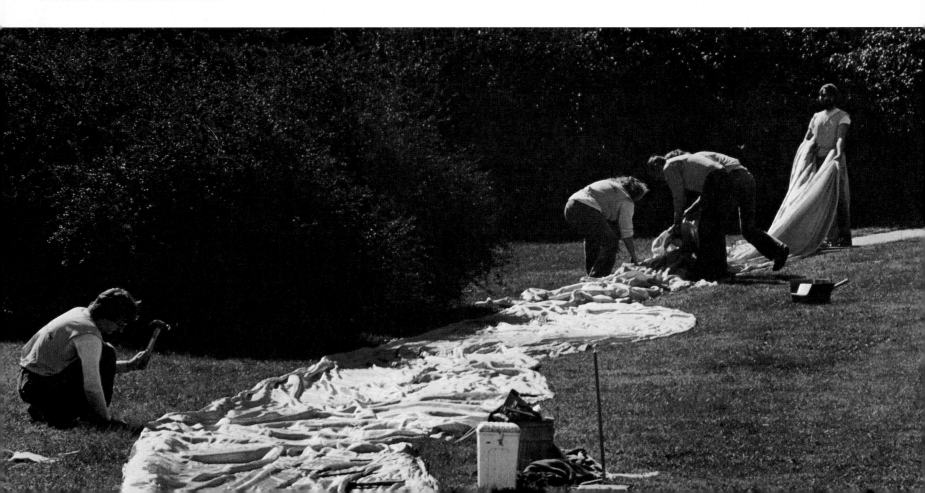

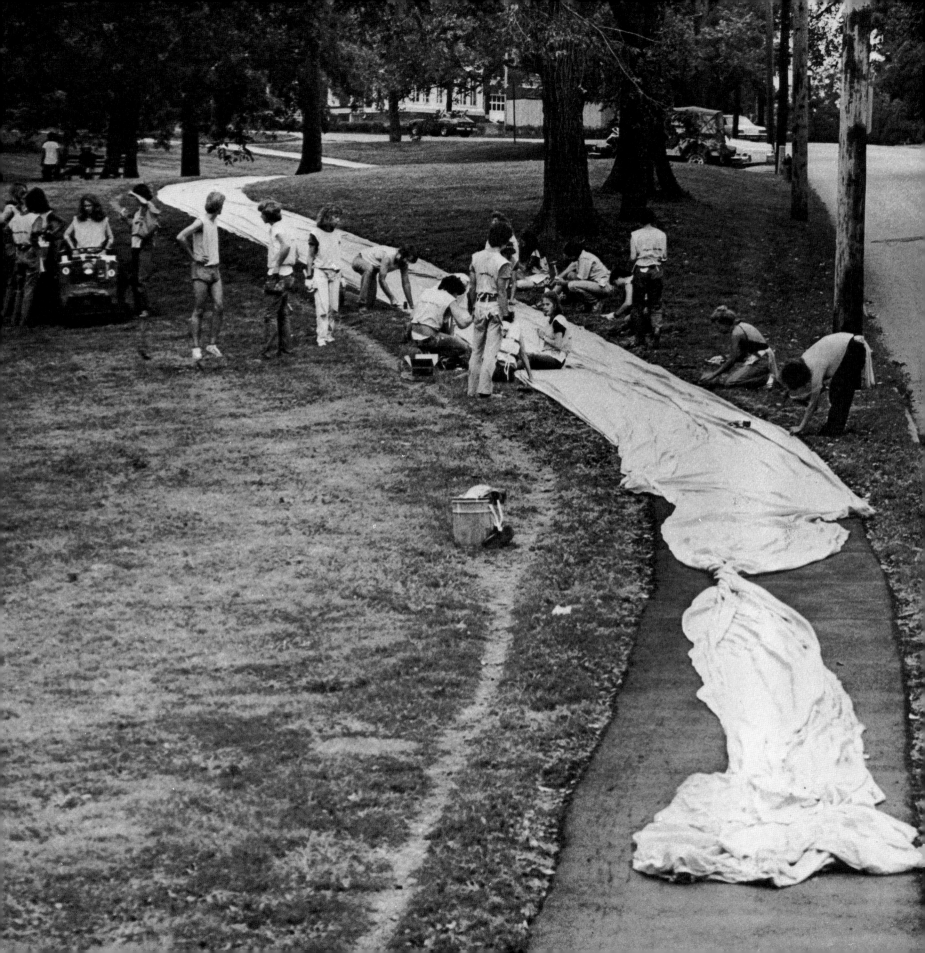

34,500 spikes of $^5/_{16}''$ diameter were driven through the grommets.
A 7-inch or 12-inch length was used according to the type of soil.

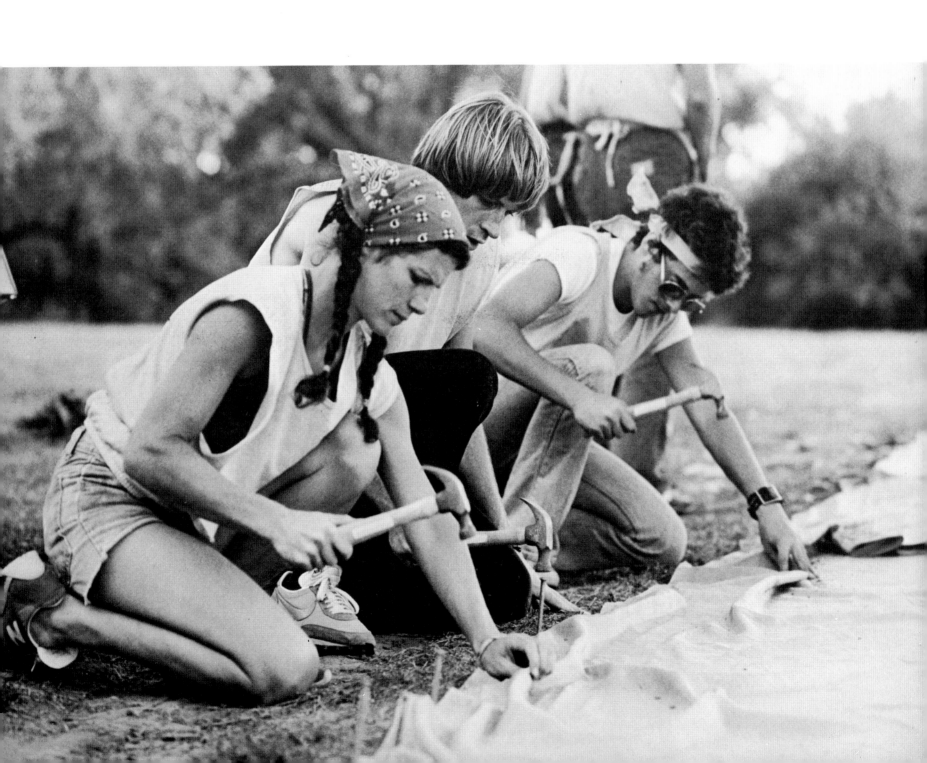

Although most of the workers were inexperienced in the use of the
hammer, there were no smashed thumbs.

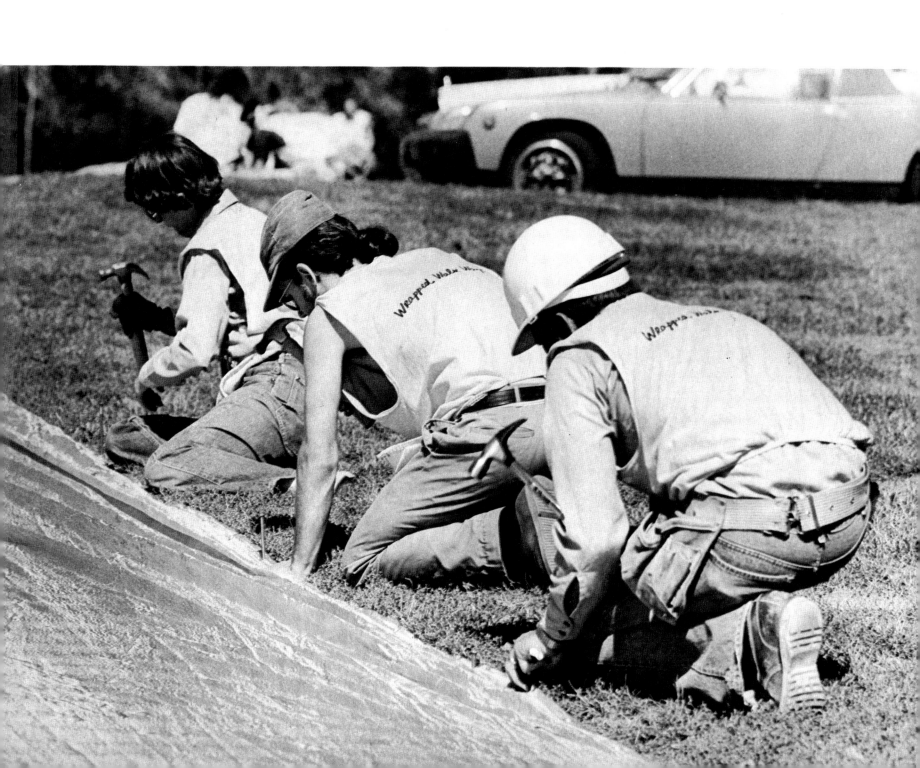

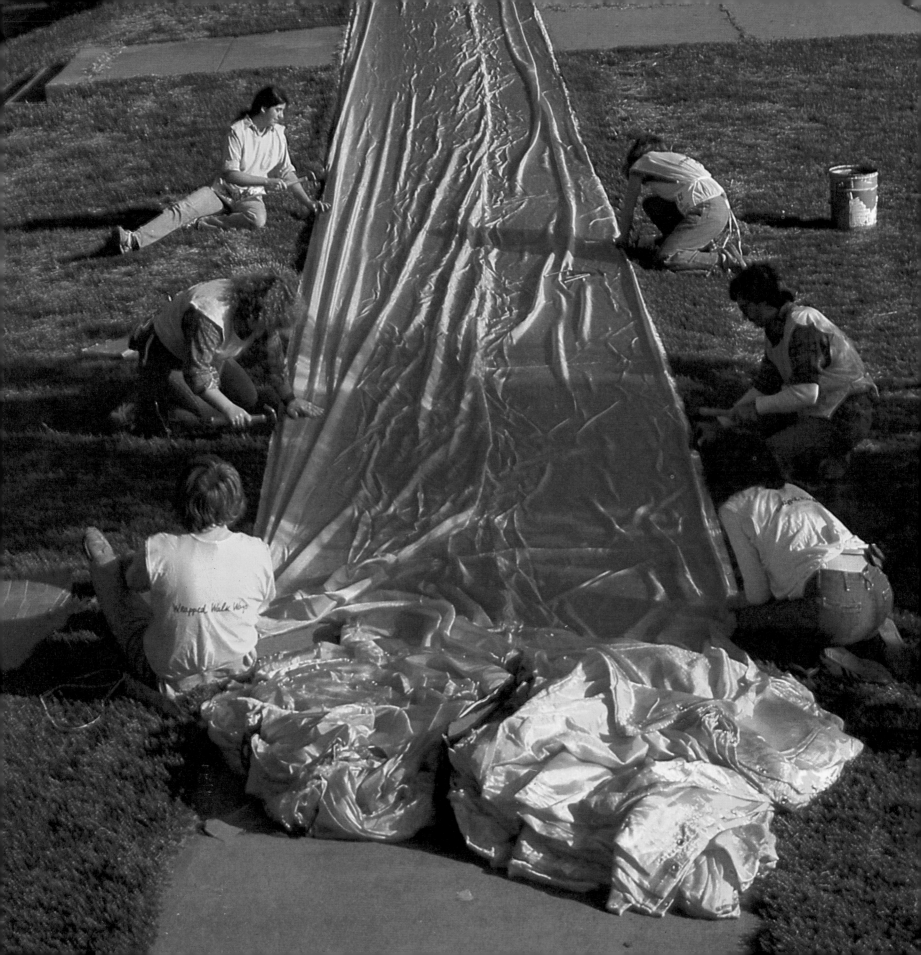

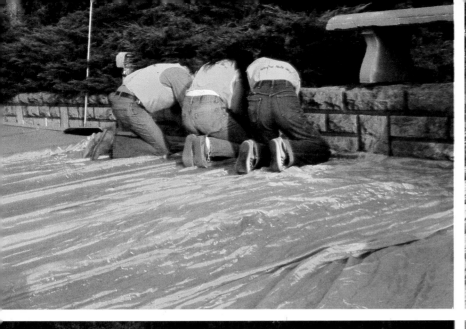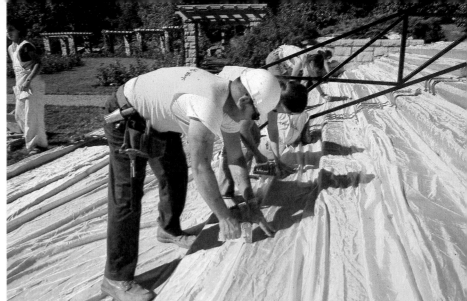
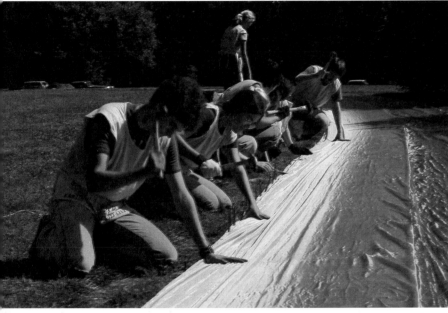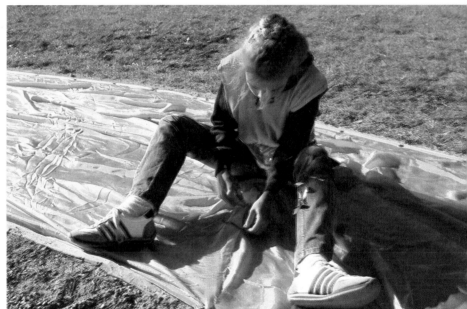
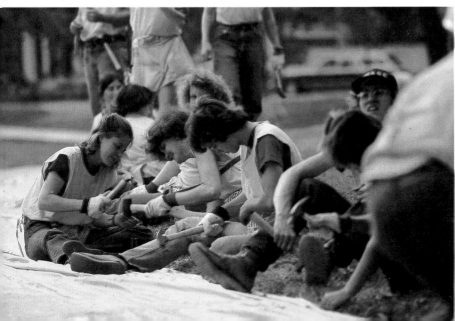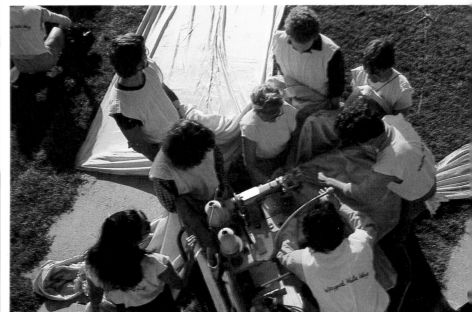

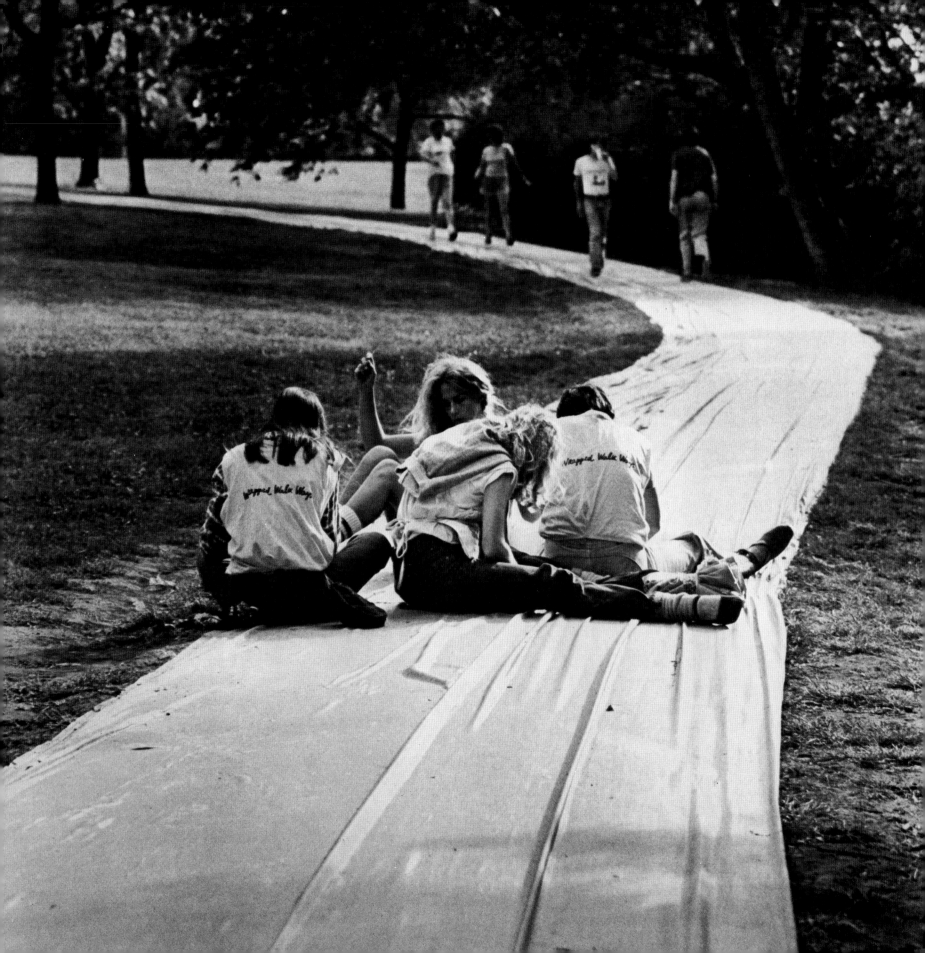

People went on using their park during the installation.

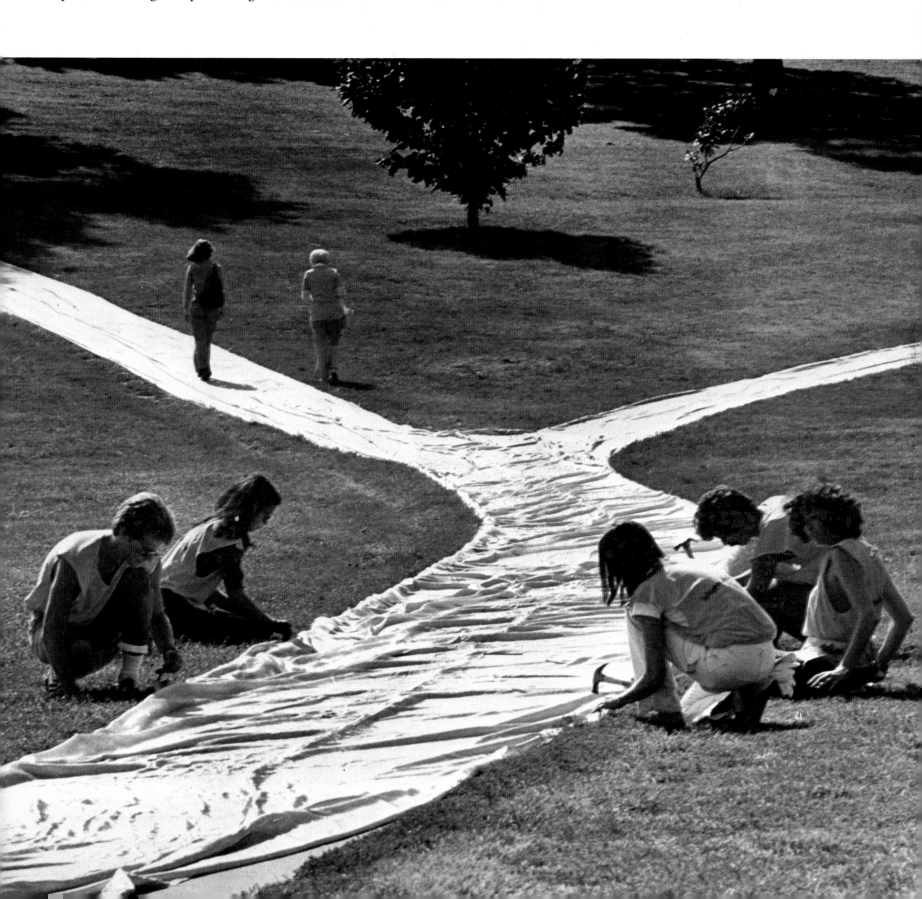

The 60,000 staples needed to secure the fabric over the wooden platform on the stairways were pre-painted a saffron color.

Hand sewing turned out to be the most time-consuming task of the installation and one that required everybody's effort and skill.

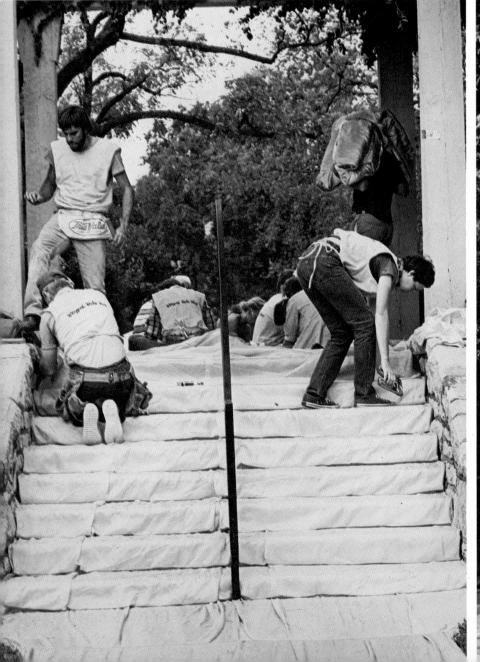

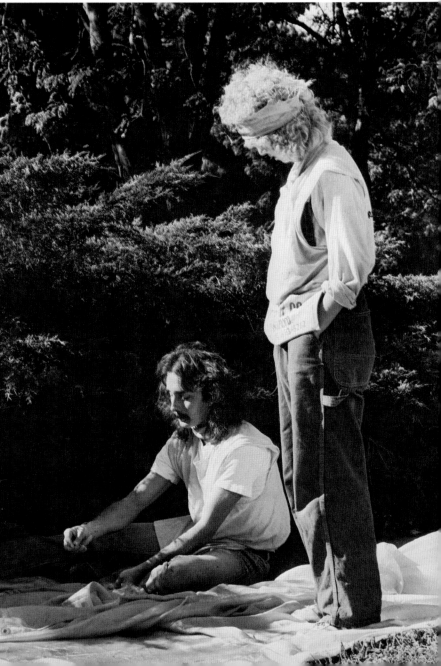

On the first day of installation, the long, winding jogging paths were covered. The work continued under a heavy downpour and lasted until after dark. The second and third days were given over to the rose garden and pavilion, both of which required an enormous amount of detailed work.

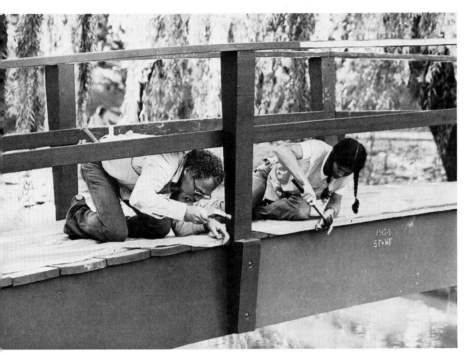

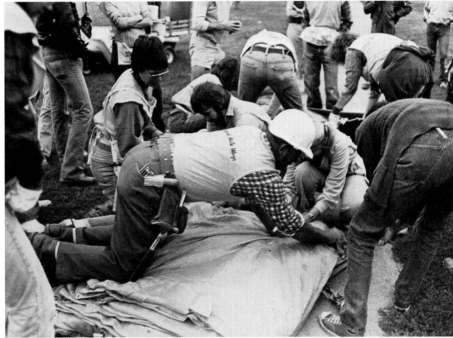

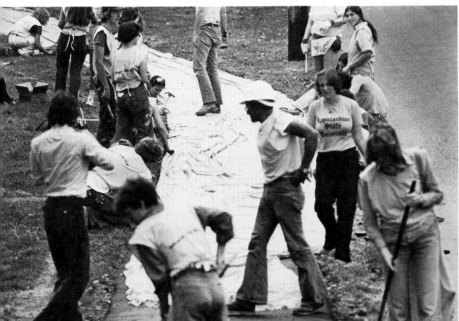

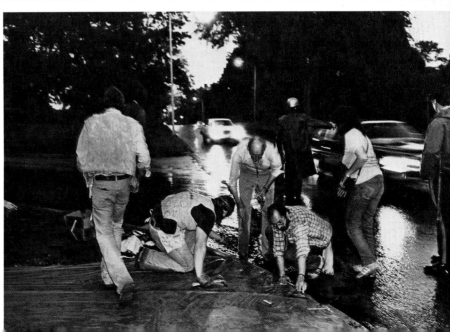

Jo Fuller (left) helping with the practically endless task of hand stitching.

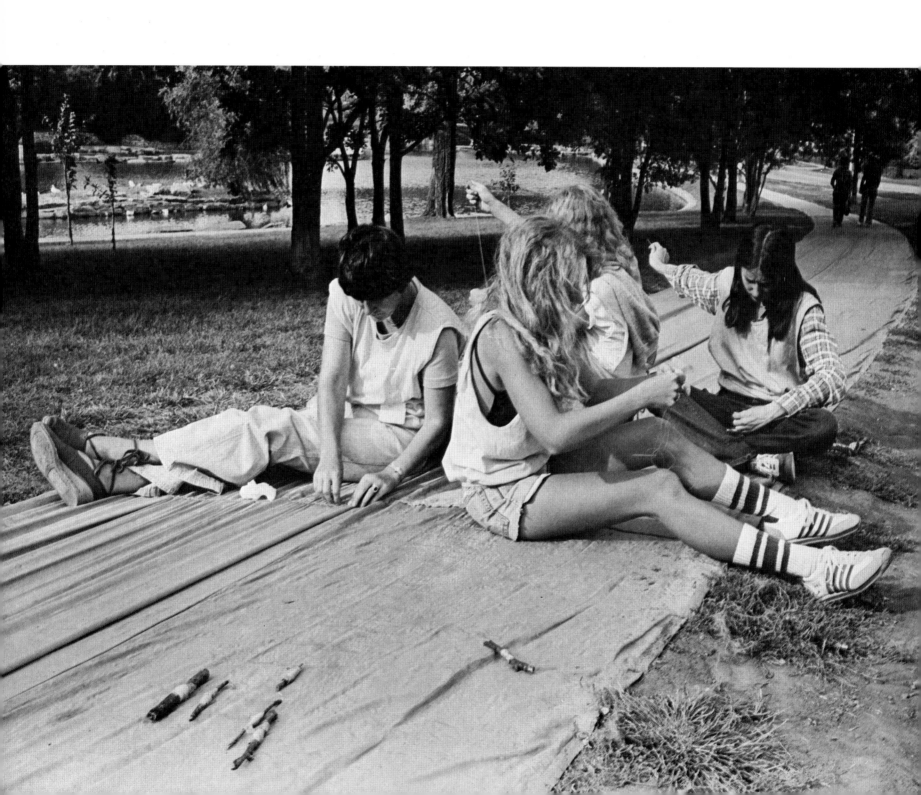

Ruby, a professional seamstress, at one of three portable sewing machines. The machines, on wheels and with their own generators, were set up to handle some of the sewn connections between rolls of fabric.

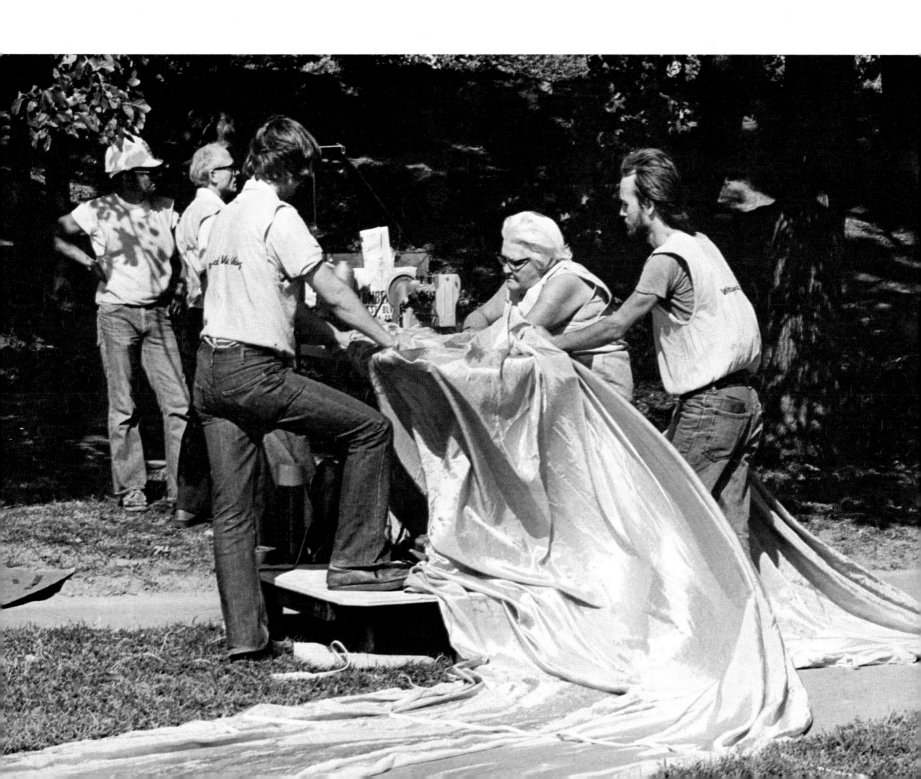

Phyllis Dougherty managed a small field office located in the maintenance building of Loose Park. In addition to organizing the delivery of supplies such as thread, needles, scissors, spikes, and grommets on four golf carts circulating around the park, Phyllis ordered hundreds of sandwiches and drinks for the work crews.

Christo making last-minute alterations.

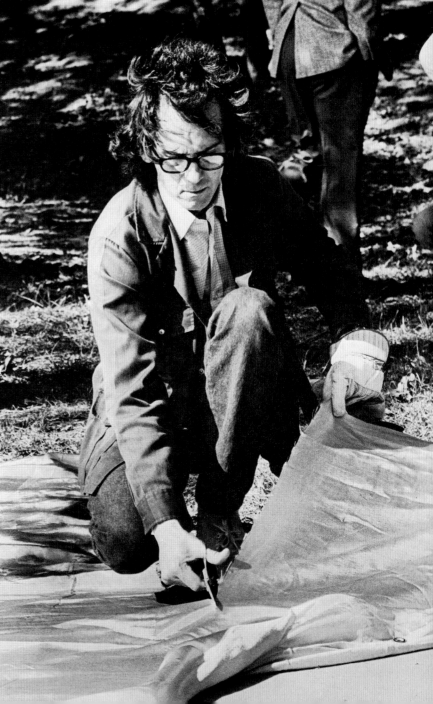

Jim Fuller adjusting the joining of the fabric before calling a sewing team.

Mitko Zagoroff with Jeanne-Claude Christo checking some last-minute details. Beginning in 1968, Mitko has worked with Christo on *5600 Cubic Meter Package*, *Valley Curtain*, *Running Fence*, and the *Ocean Front* projects.

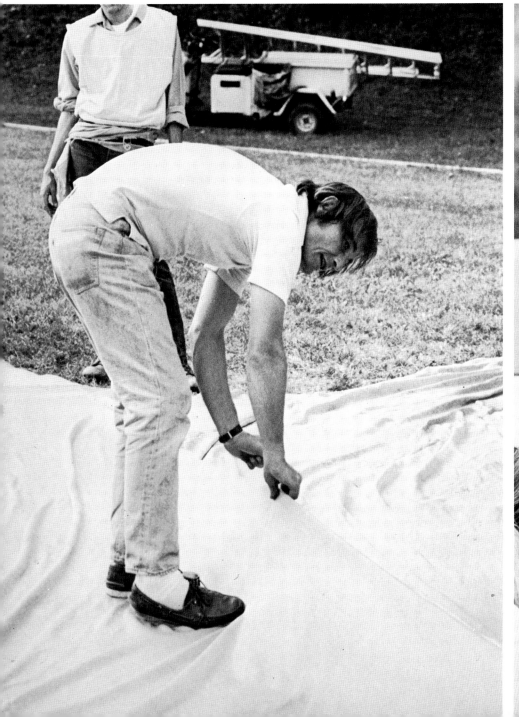

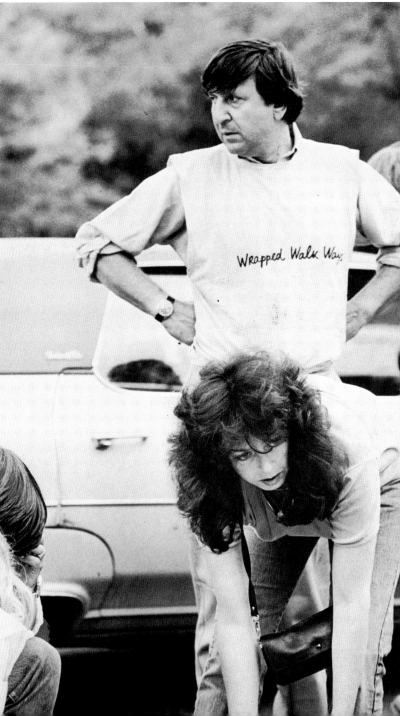

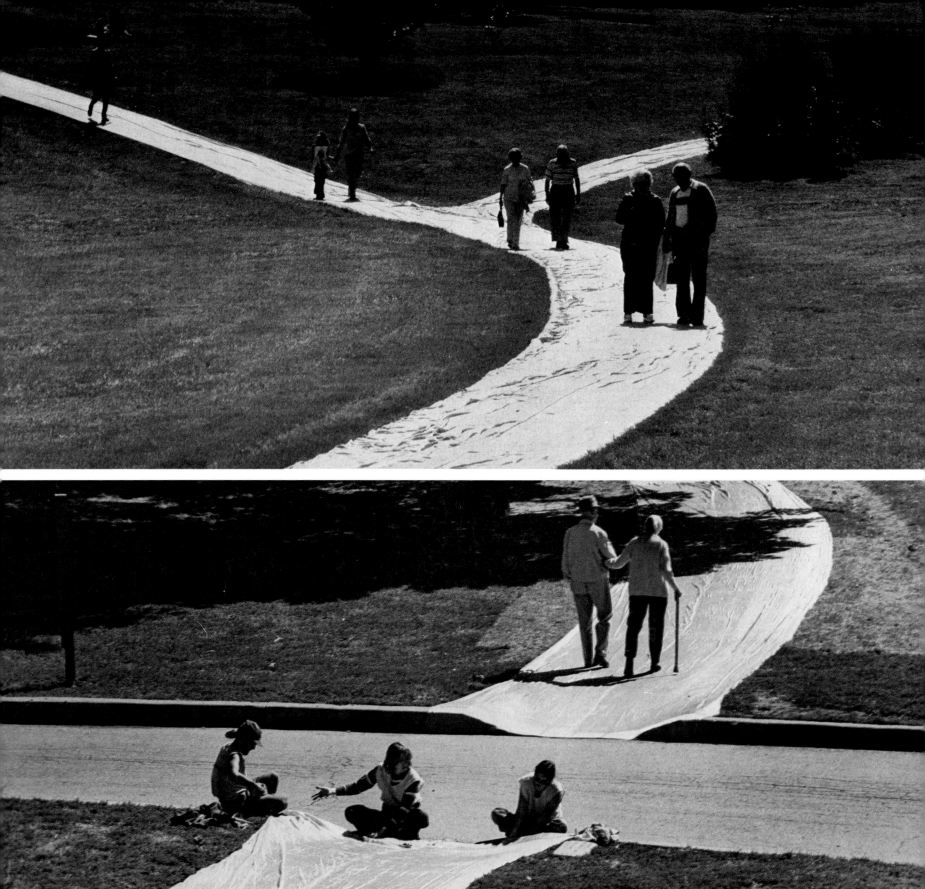

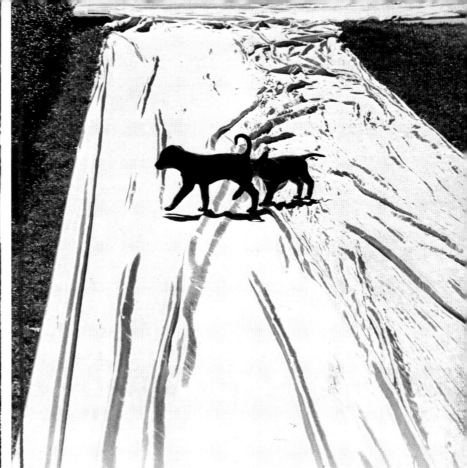
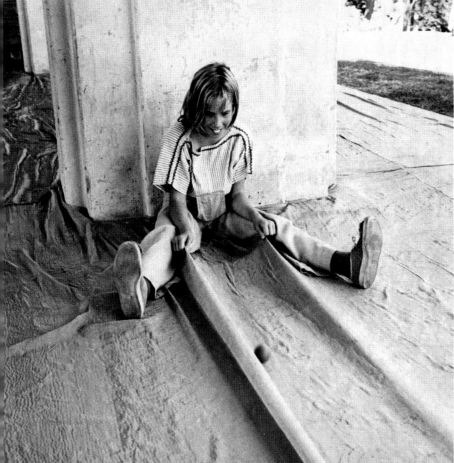
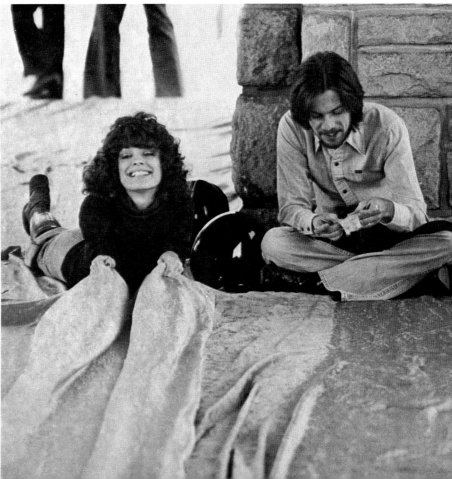

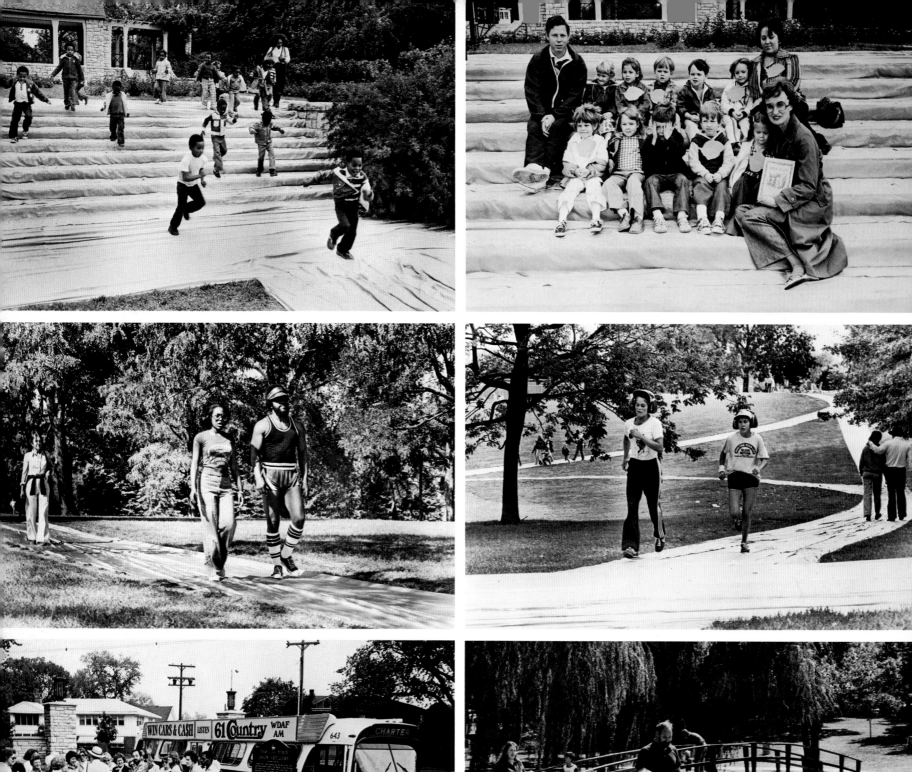
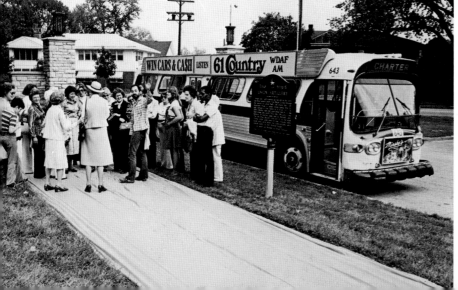
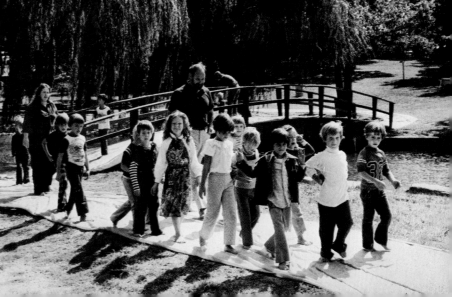

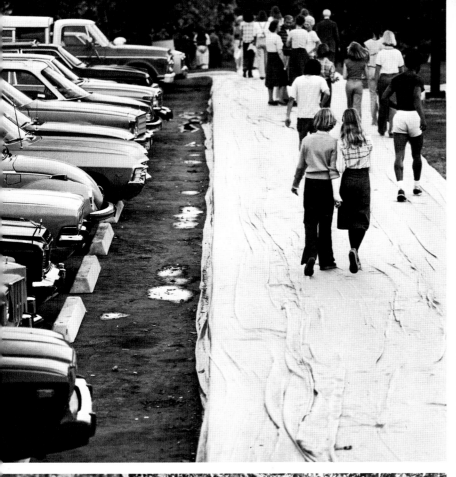
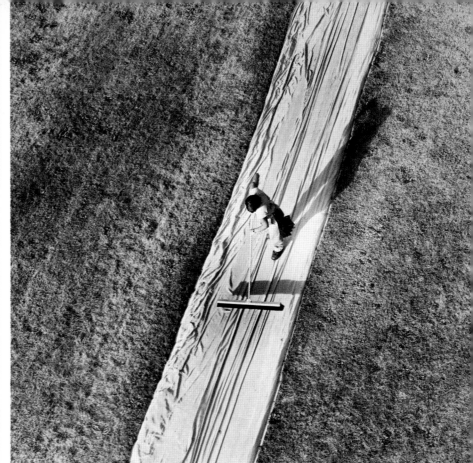
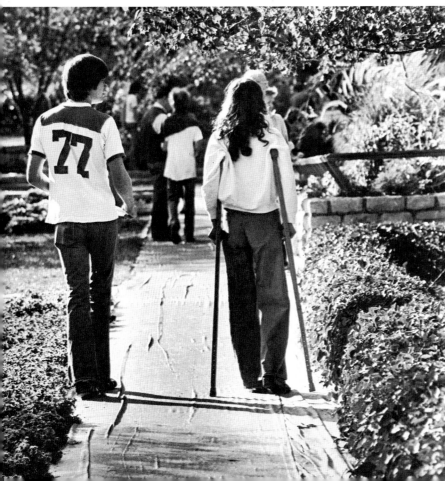
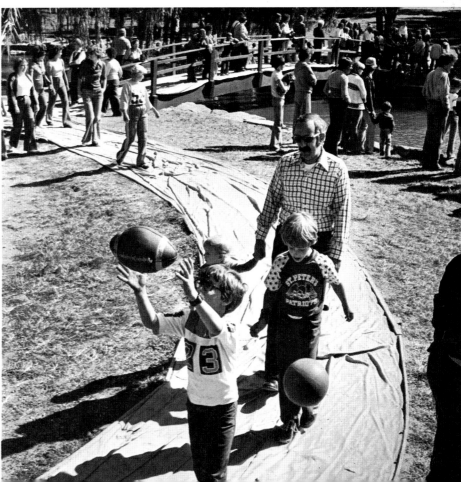

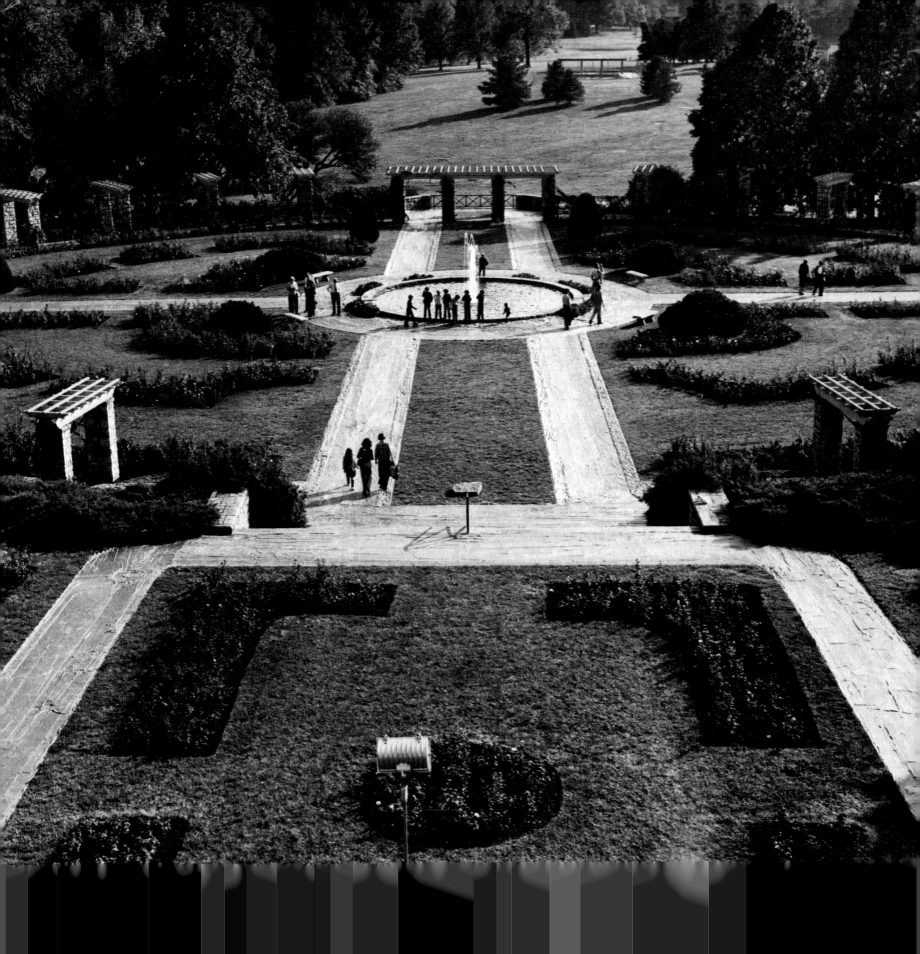

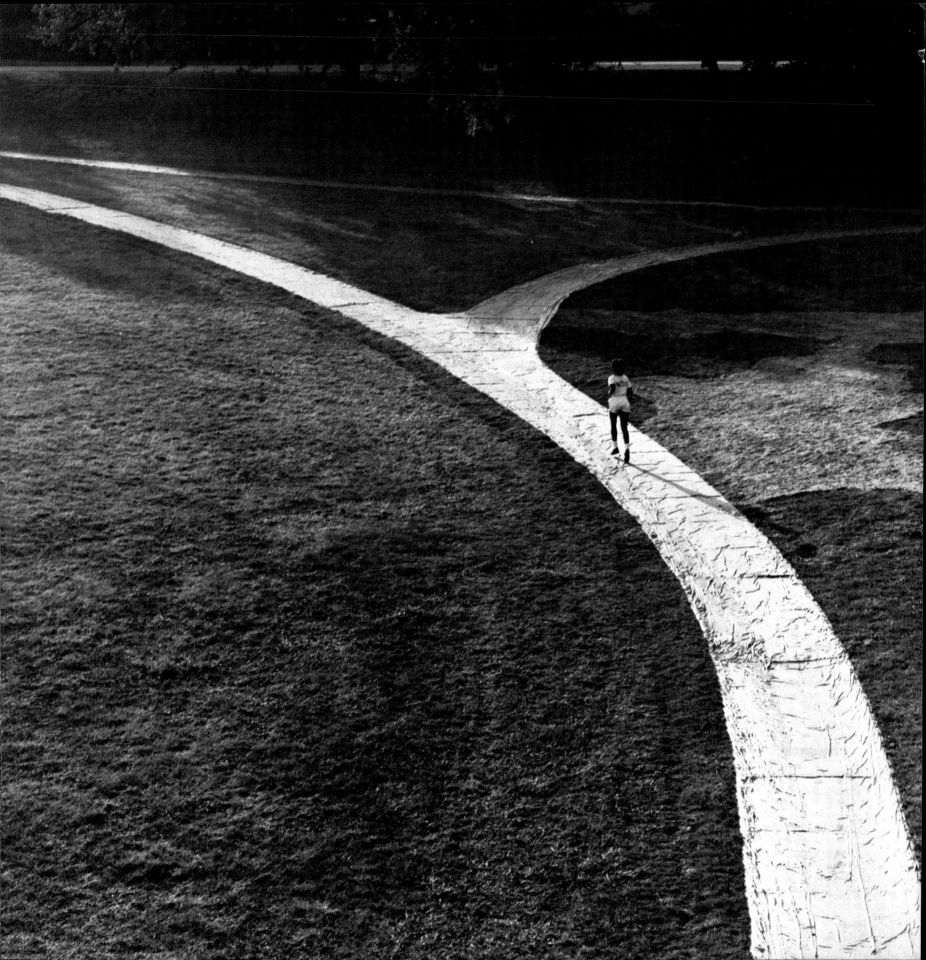

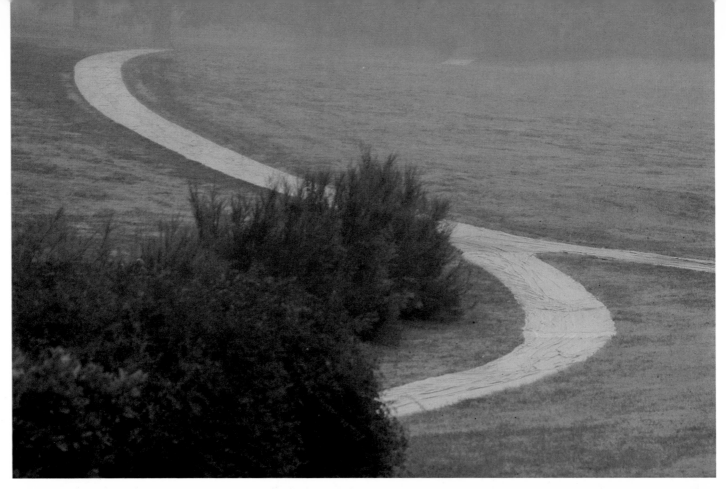

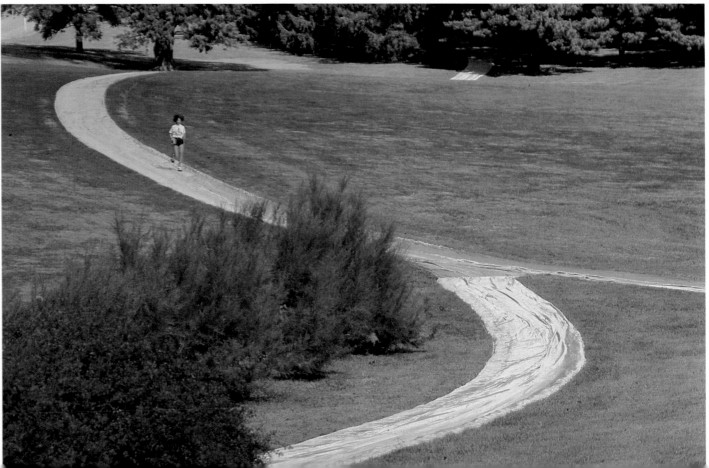

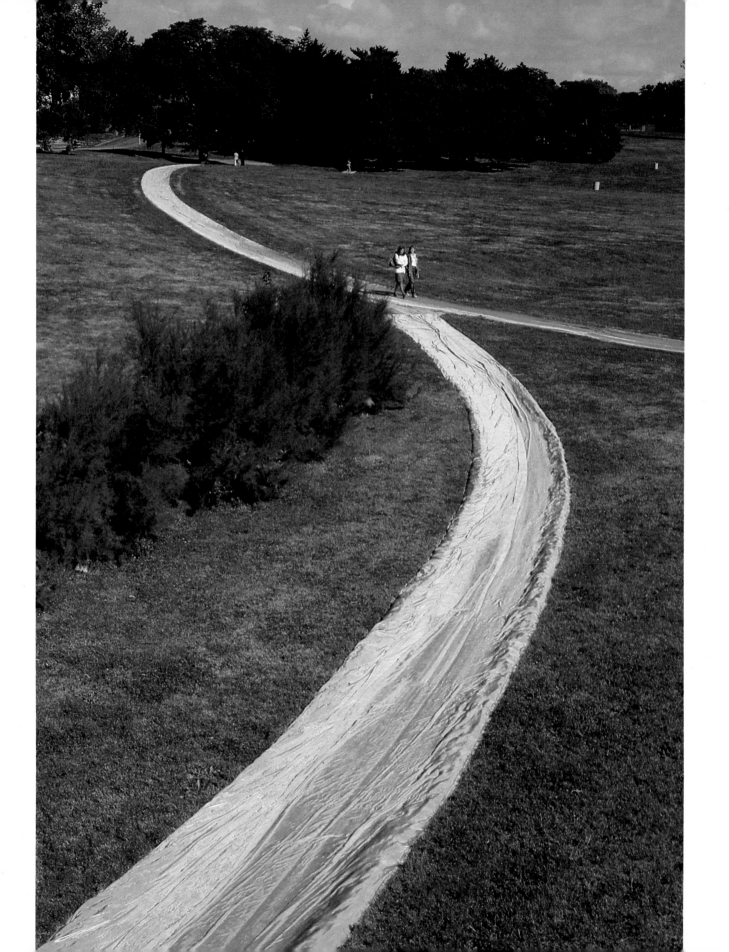

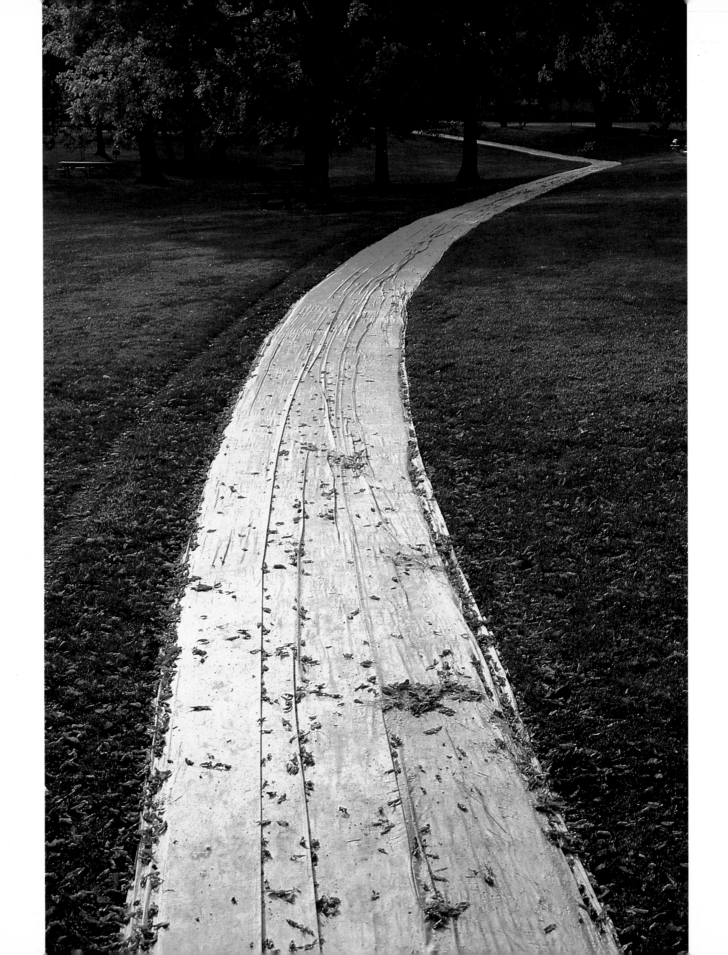

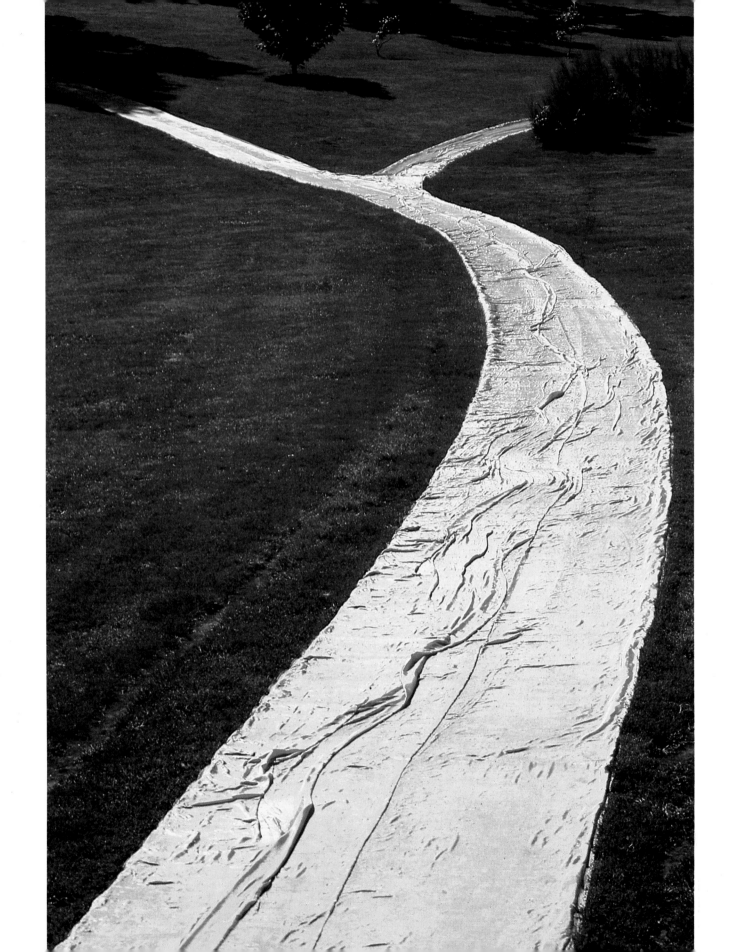

Changing light played constantly on the fabric. Full sun made it appear as rivulets of liquid gold.

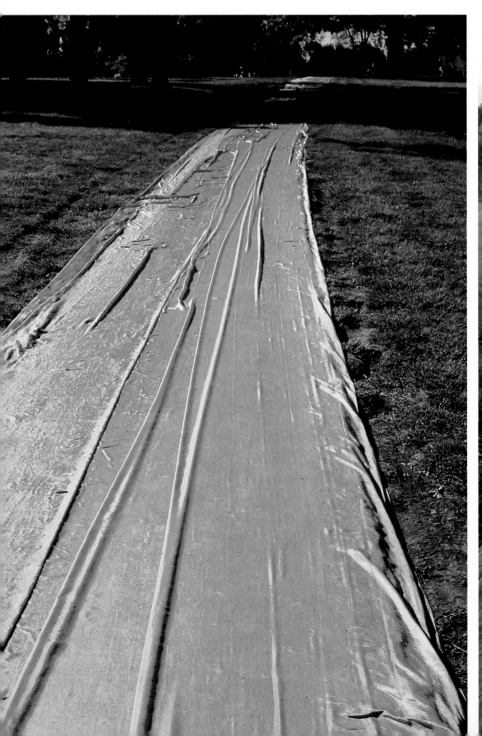

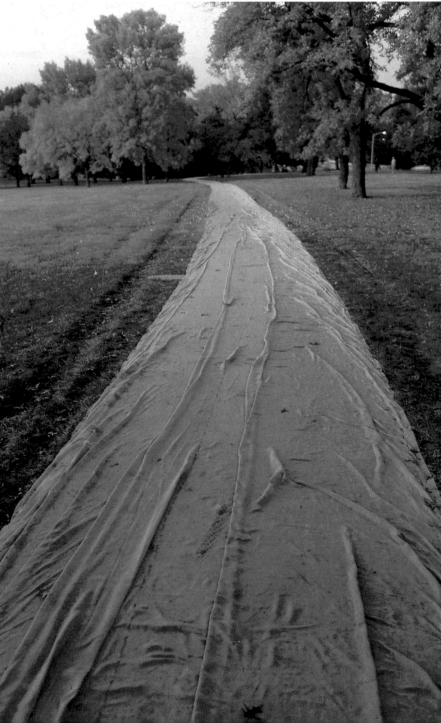

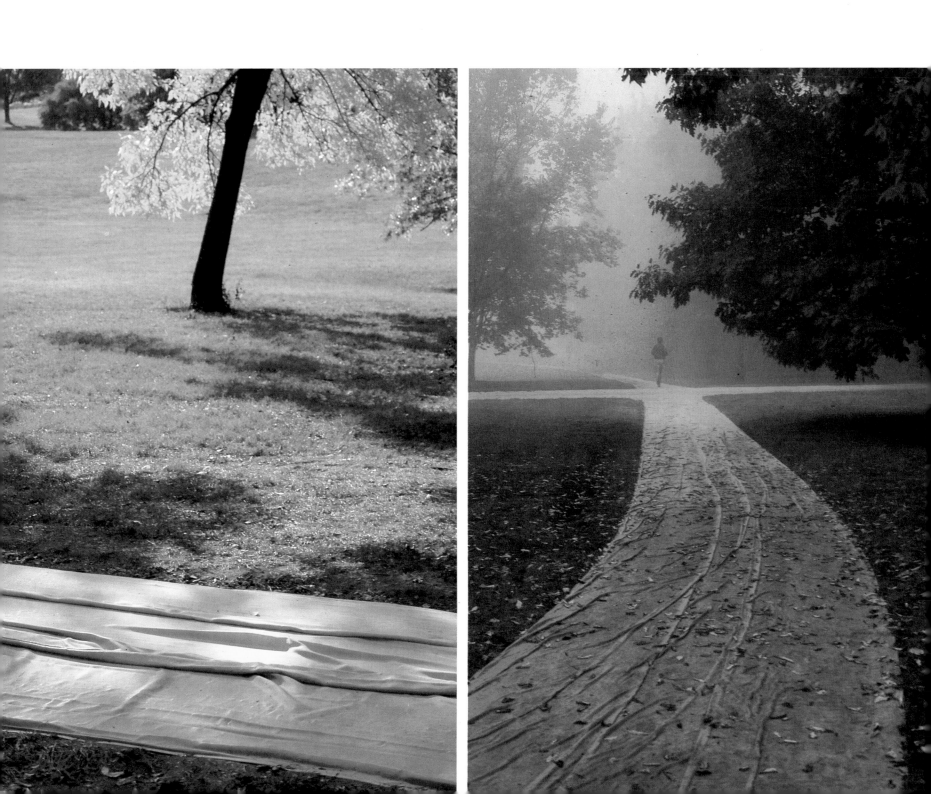

Variations in the saffron color in different dye lots added interest and gave unexpected patterns to certain areas of the covering.

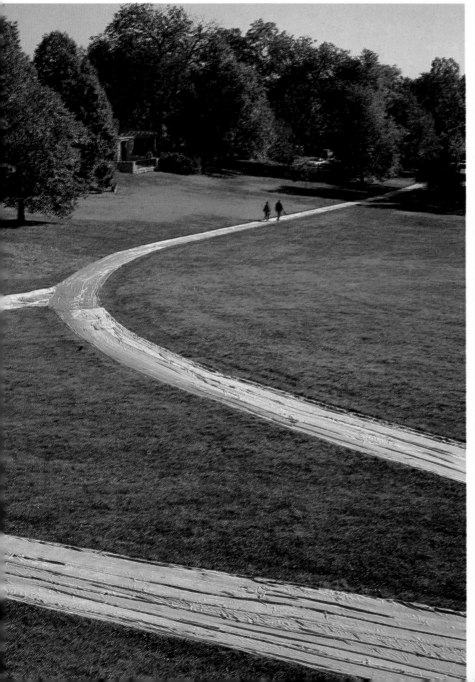

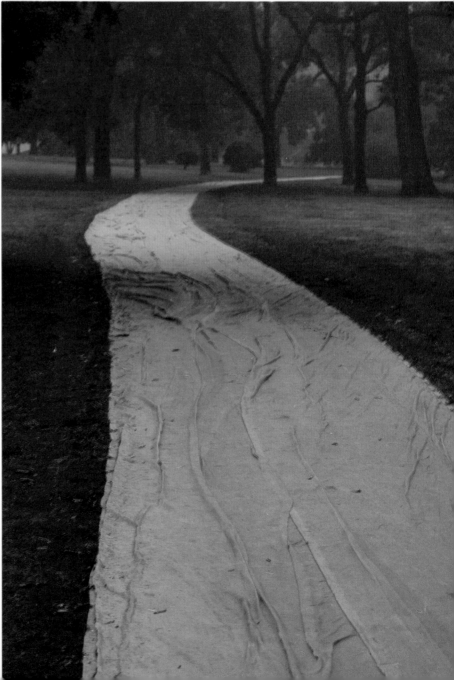

The path on the north and west side of the pond winds through birches. These gravel paths required frequent sweeping by the maintenance crew during the installation of the fabric.

FOLLOWING PAGES: Christo was thrilled with the Loose Park pond, weeping willows, and footbridge that reminded him of the setting that Monet had painted at Giverny in France.

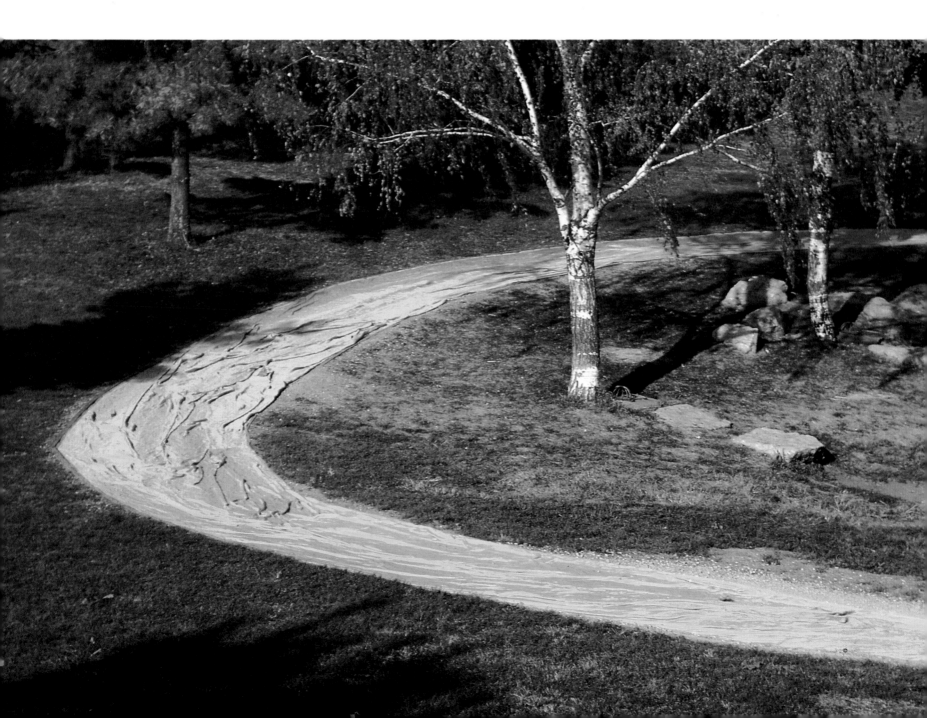

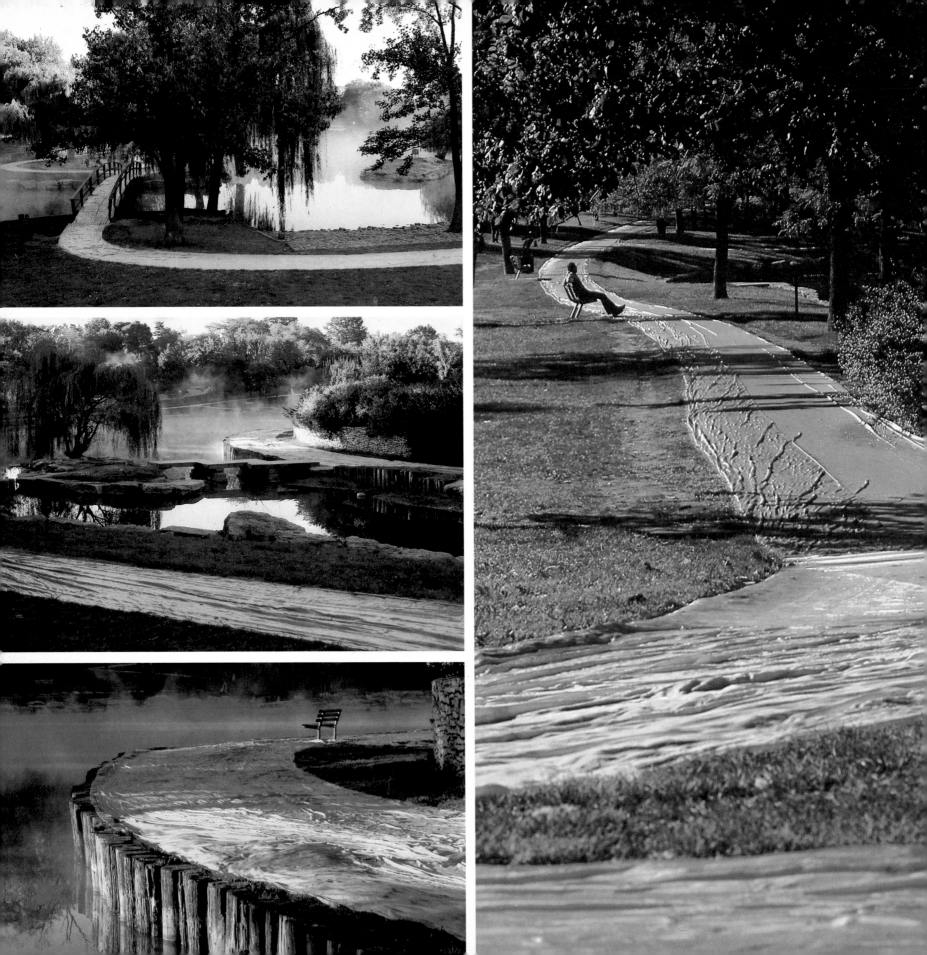

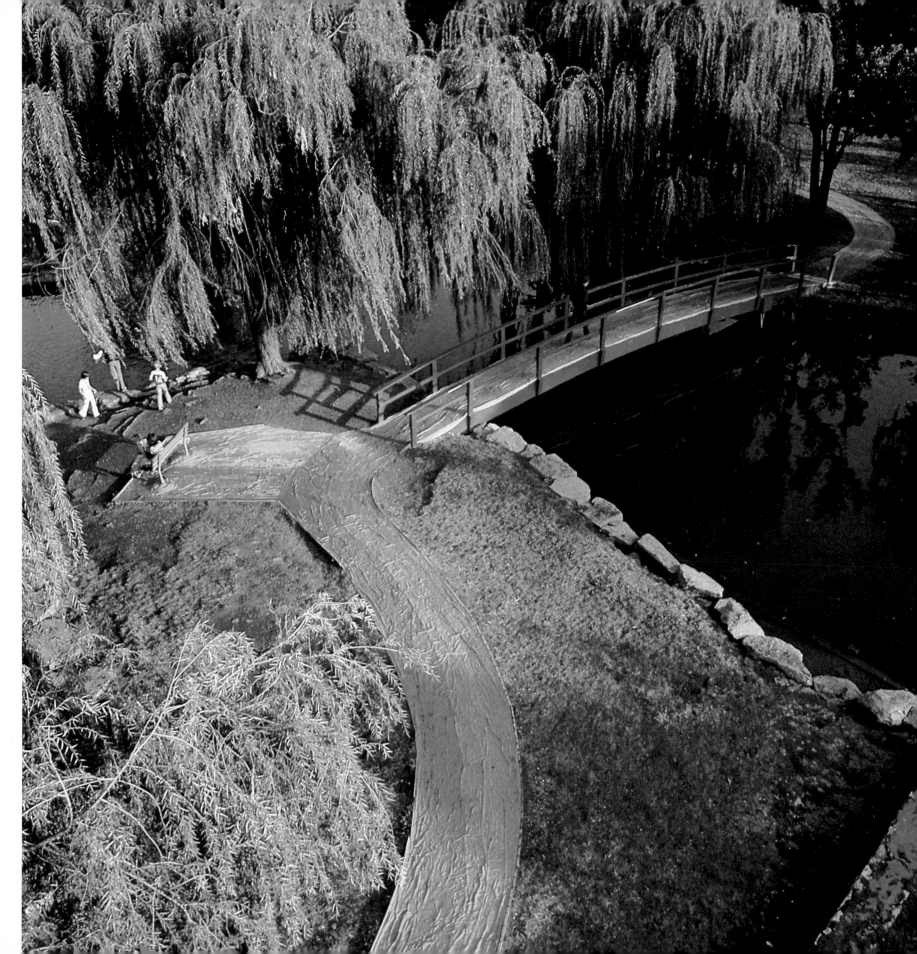

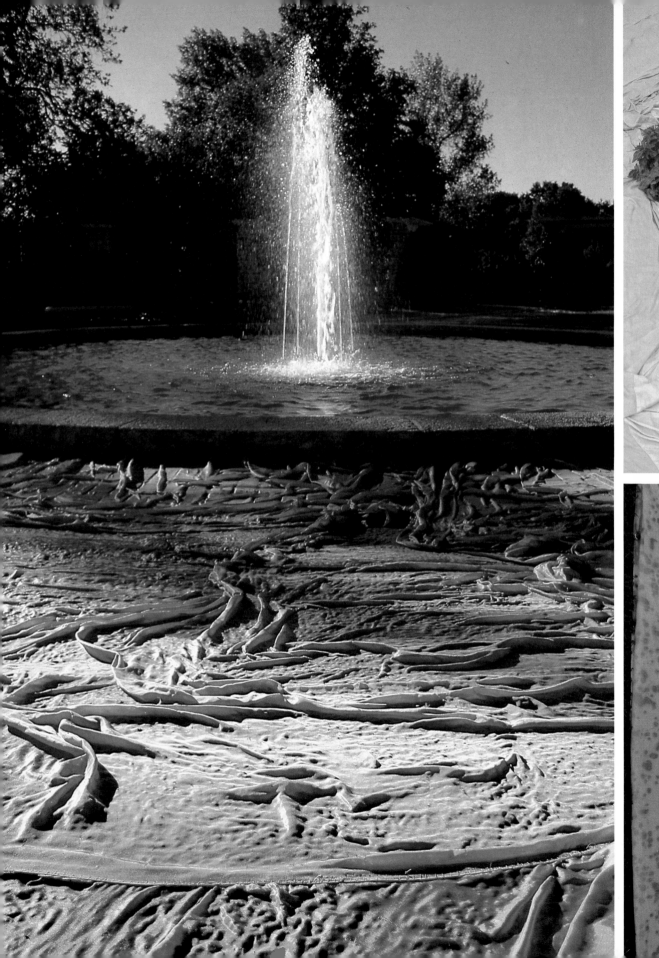

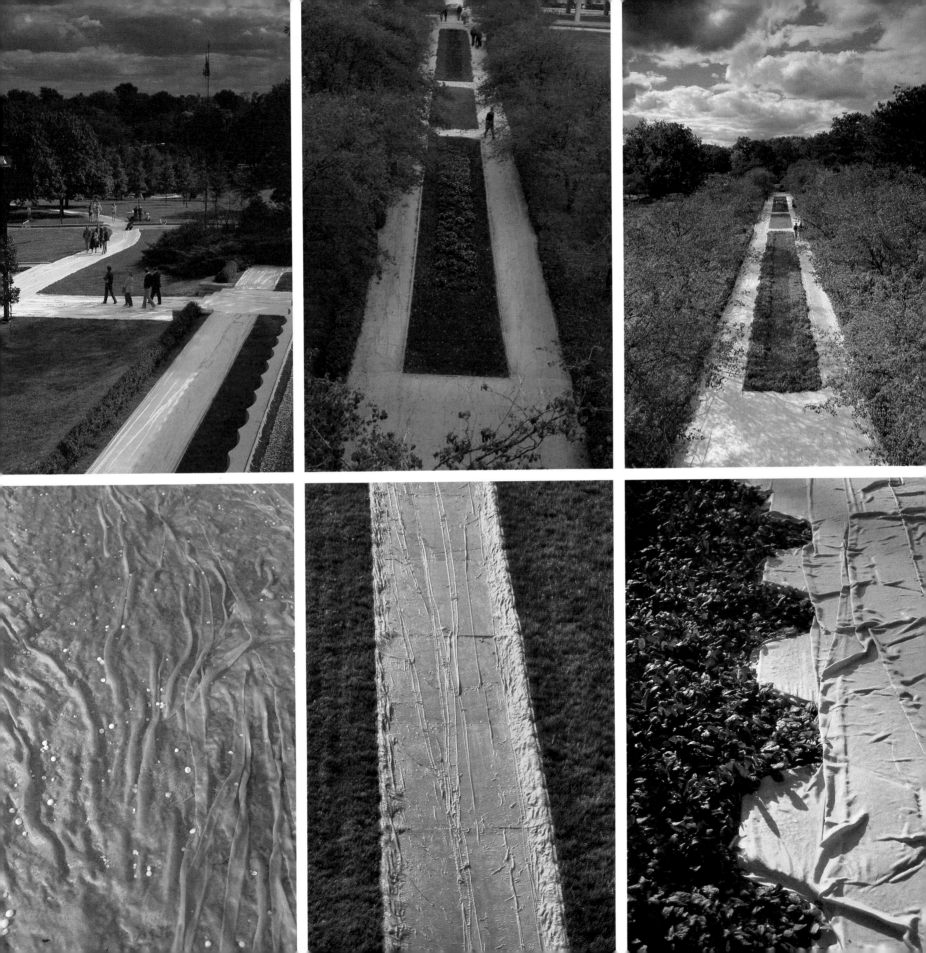

PRECEDING PAGES: Nearly every type of weather, except snow,
occurred during the scant two weeks the fabric was in place. Even hail
accumulated during an afternoon thunderstorm.

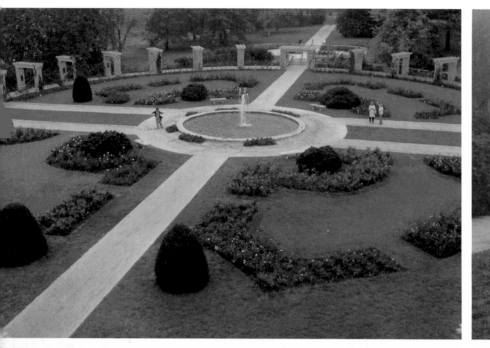

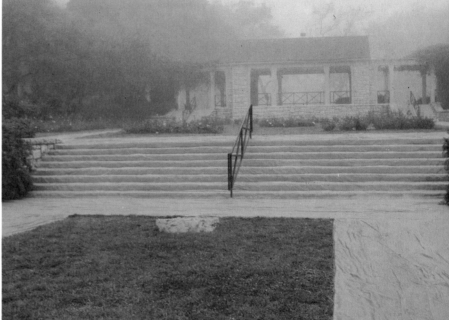

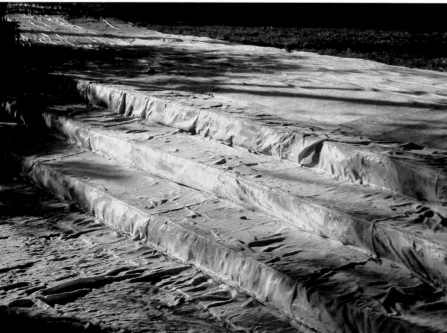

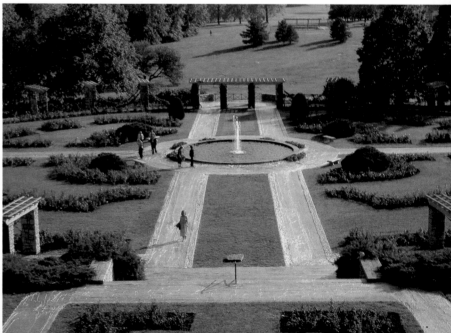

The formality of the rose garden was emphasized by the addition of
the fabric. Dedicated workers lovingly hand sewed and hand
grommeted the fabric to get an exact fit for each contour of the path.

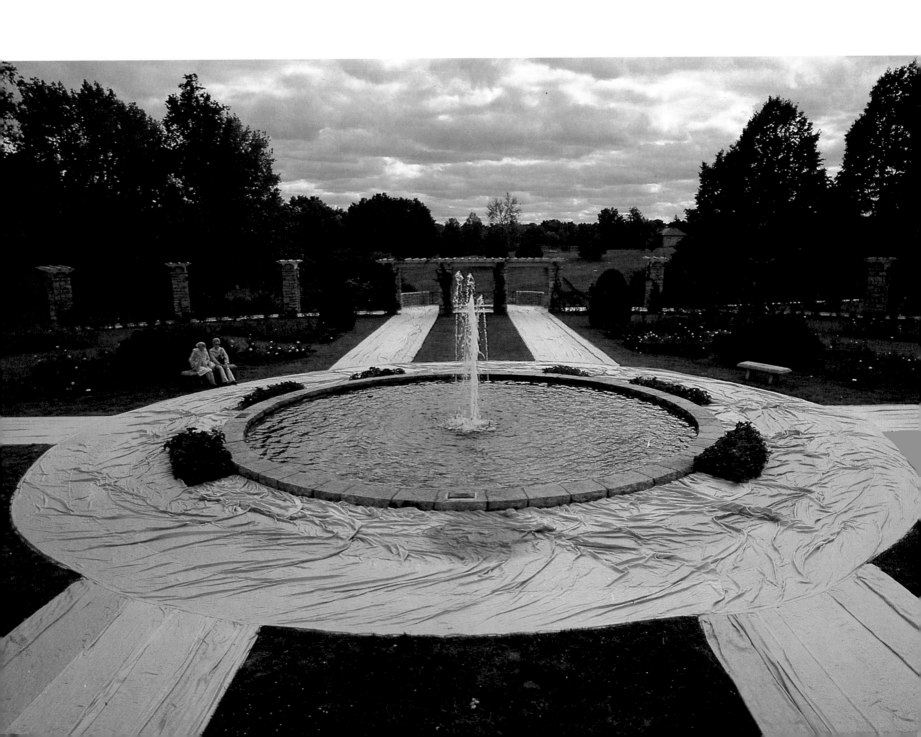

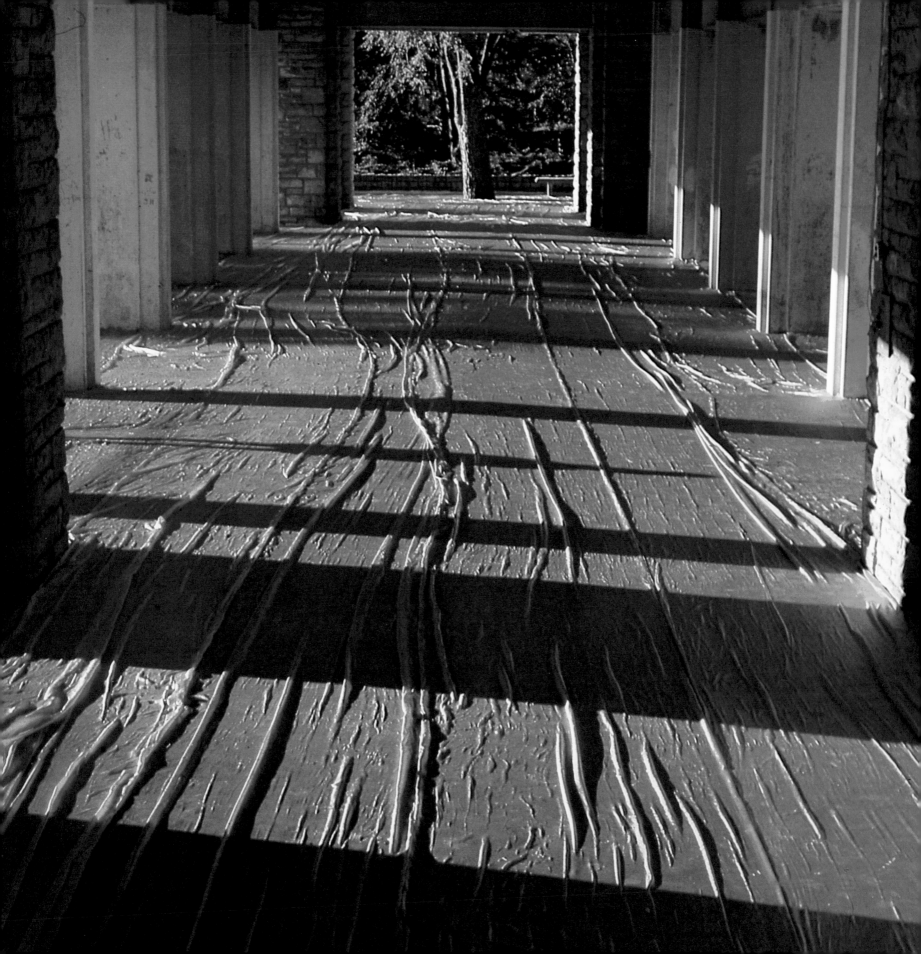

LEFT: The pavilion became like a temple suggesting the intimacy of an interior setting.

Helicopter views show the entire *Wrapped Walk Ways* project covering paths in the formal north quadrant and other more open areas of the park.

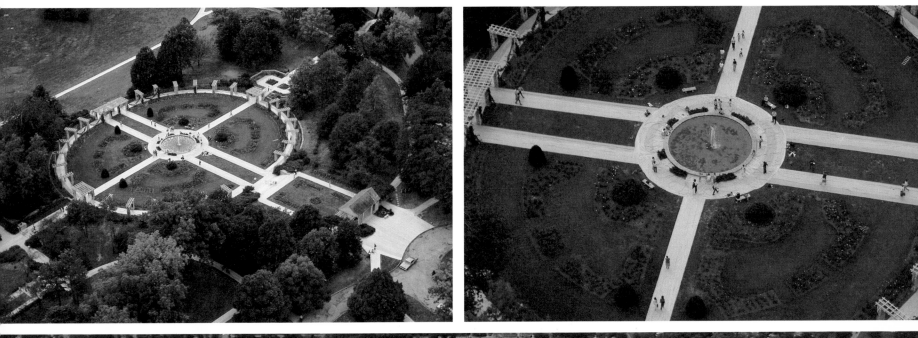

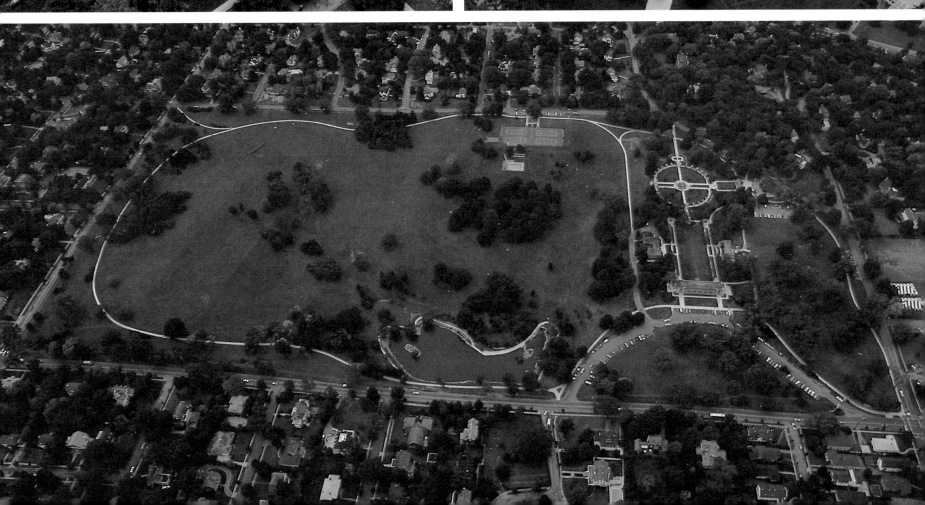

The park is completely open to the surrounding streets. Often the urge to touch the fabric caused passengers in cars stopped at the intersection (below) to hop from their vehicles and quickly run their palms over the saffron-colored walks. Despite this, traffic continued to move smoothly.

The wrapping of the walks in no way inhibited normal usage of the park by the hundreds of walkers and joggers who flocked there daily. Many runners commented that the sensation created was similar to running on a dusting of new-fallen snow.

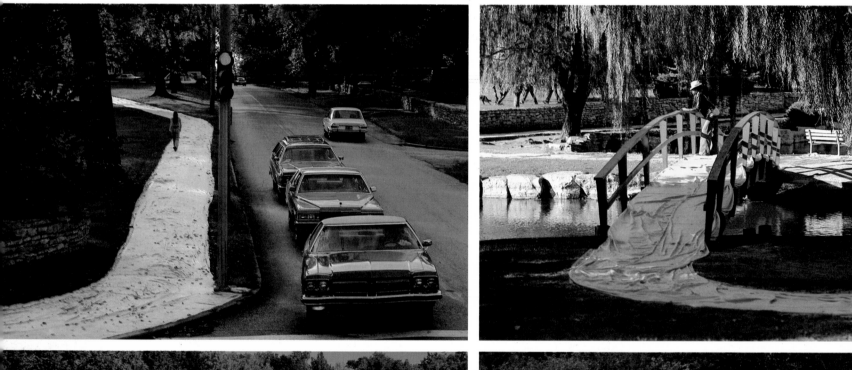

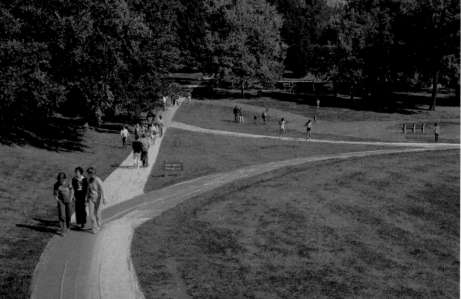

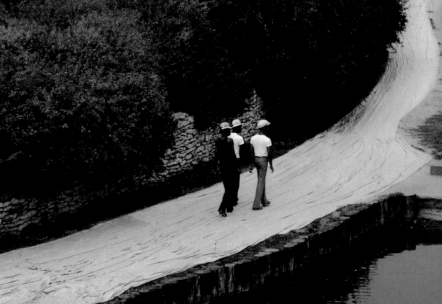

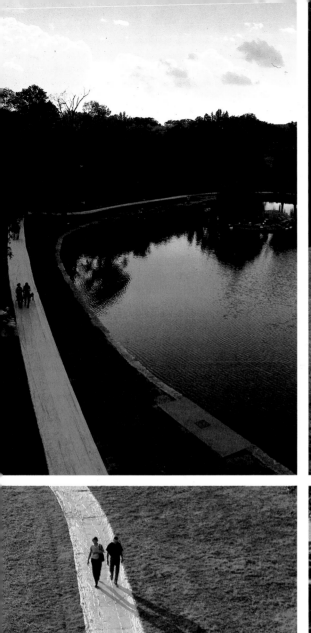
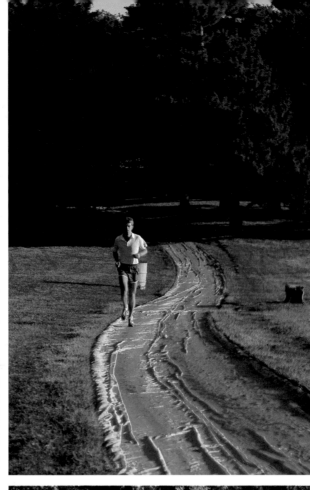
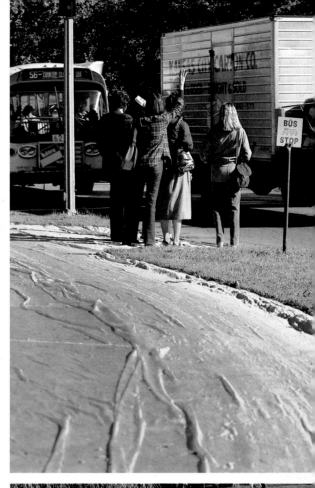
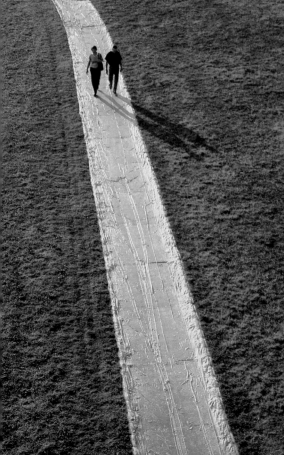
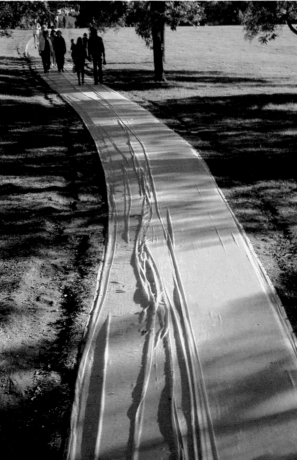
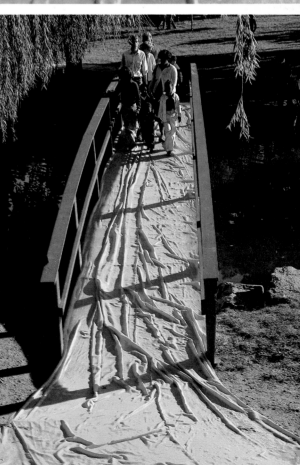

The fabric, cut thirty percent greater than the width of the walks,
lay in loose folds and gave a softening effect to ordinarily hard surfaces
of concrete and asphalt.

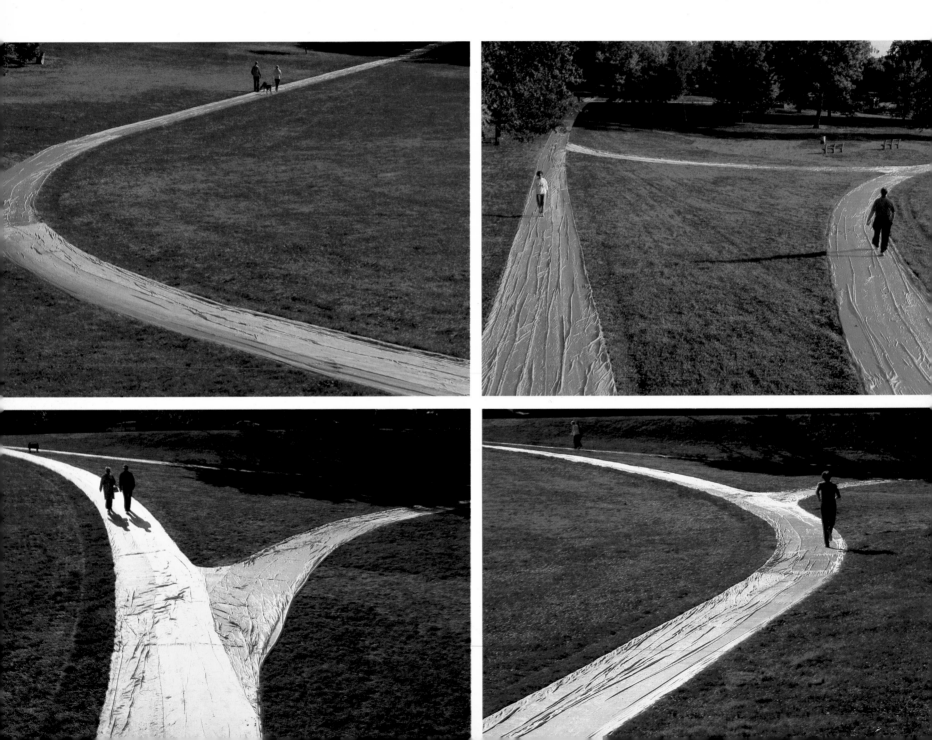

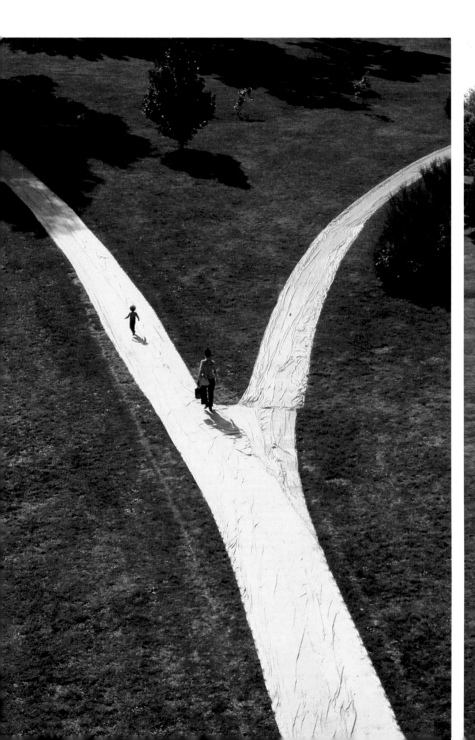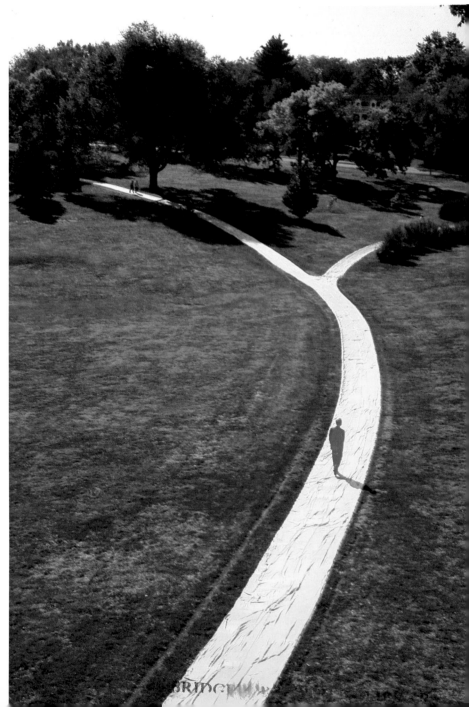

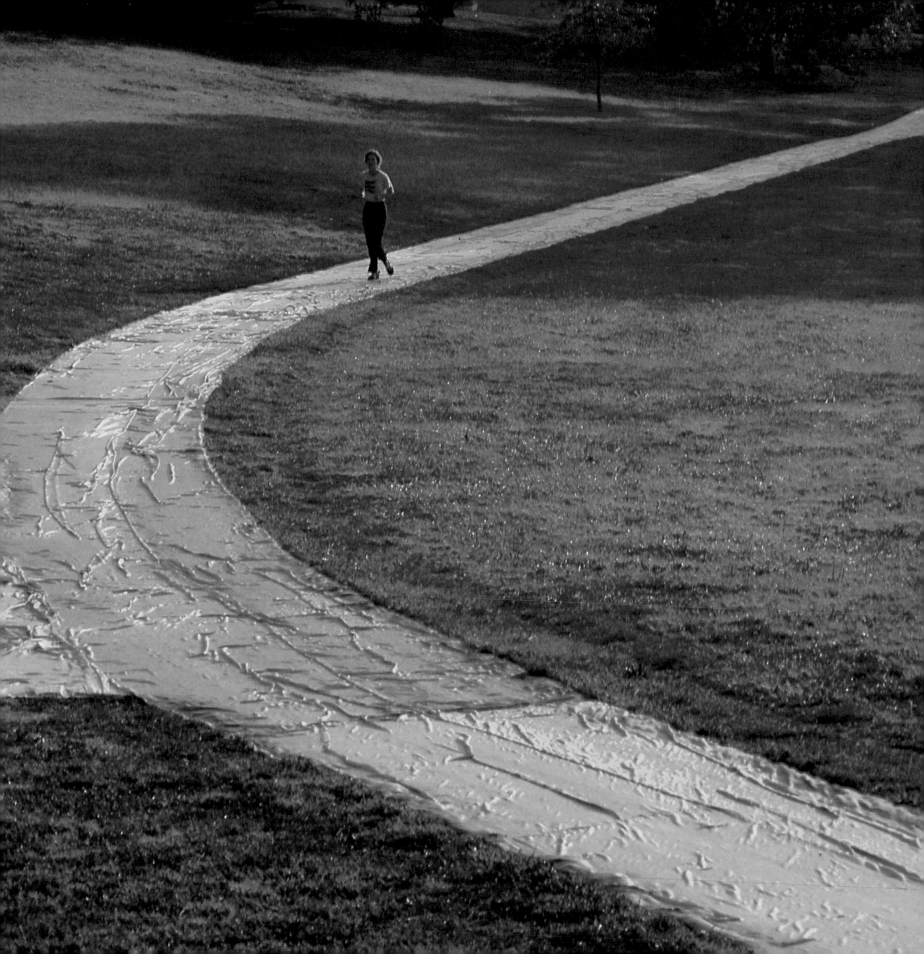

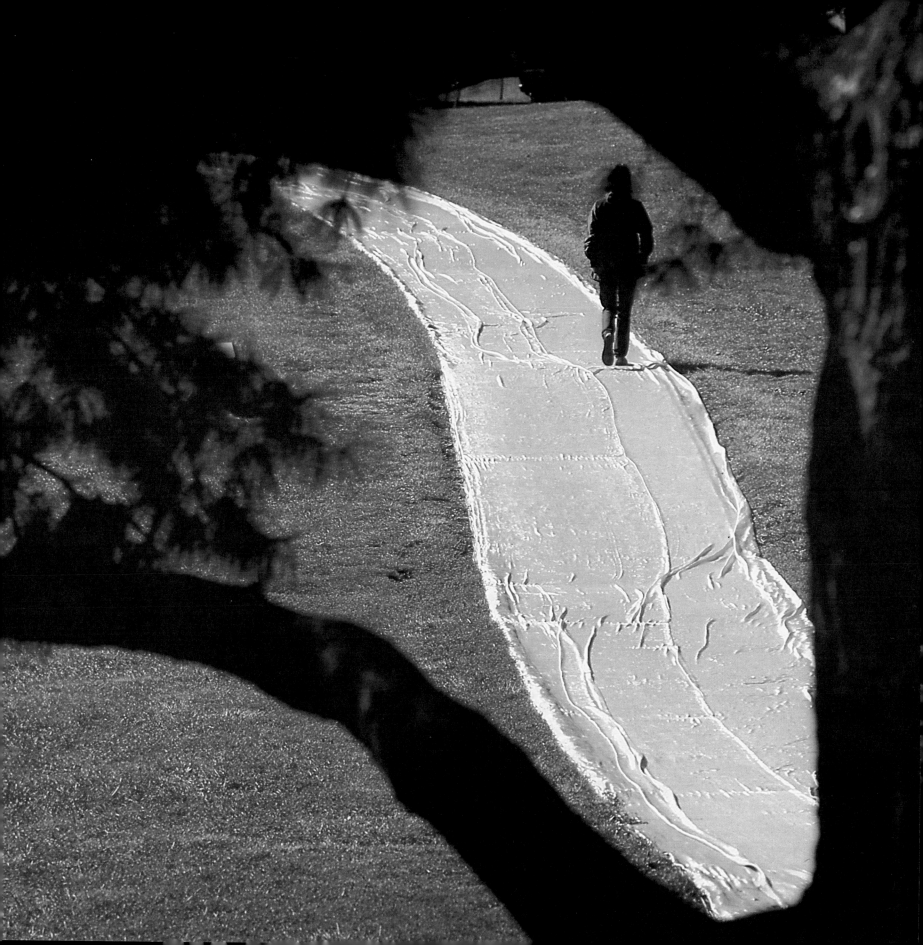

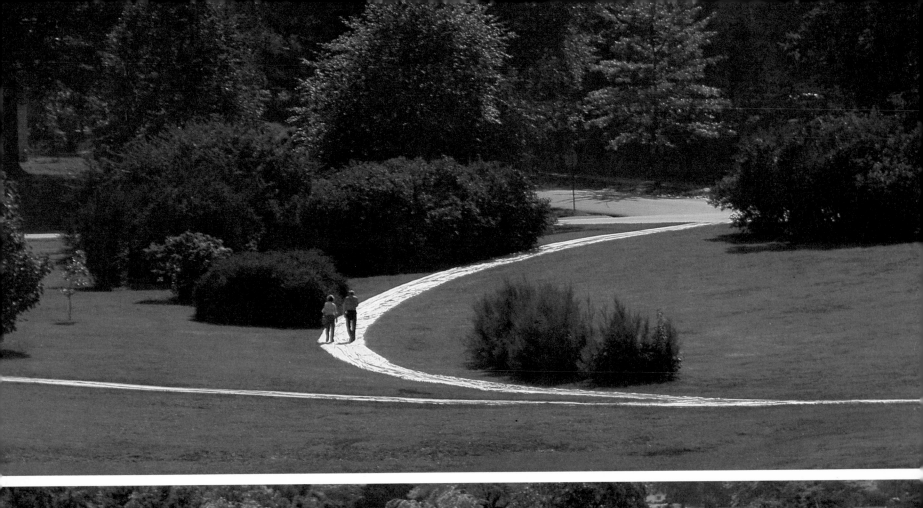
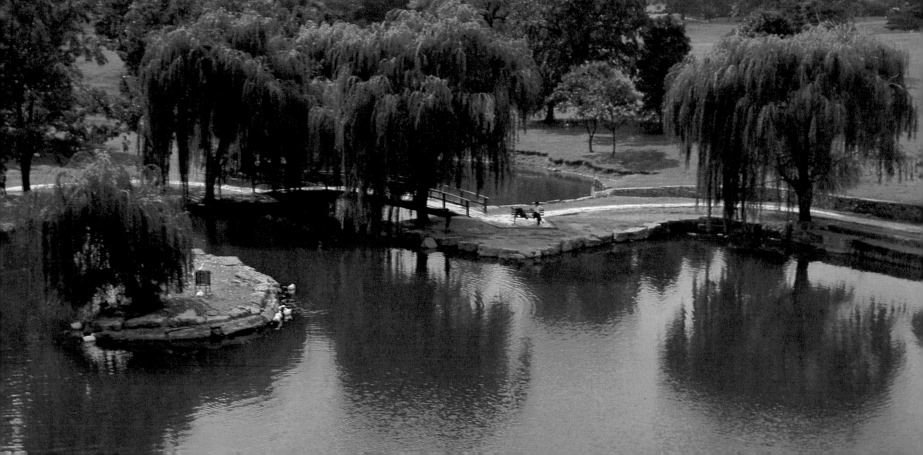

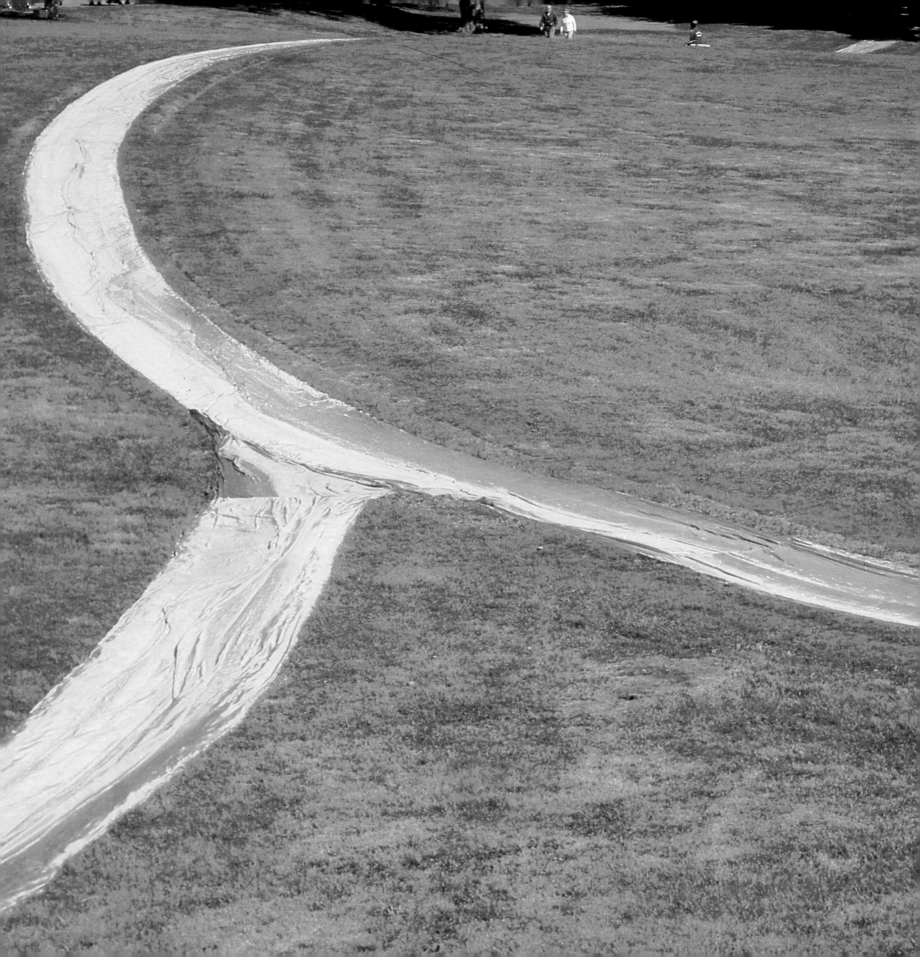

Christo found the park itself to be a changeable entity. By the time the fabric was in place, a small network of deteriorated paths had been removed by the Parks Department. Christo had sod installed to cover the brown patches of soil in the midst of green grass.

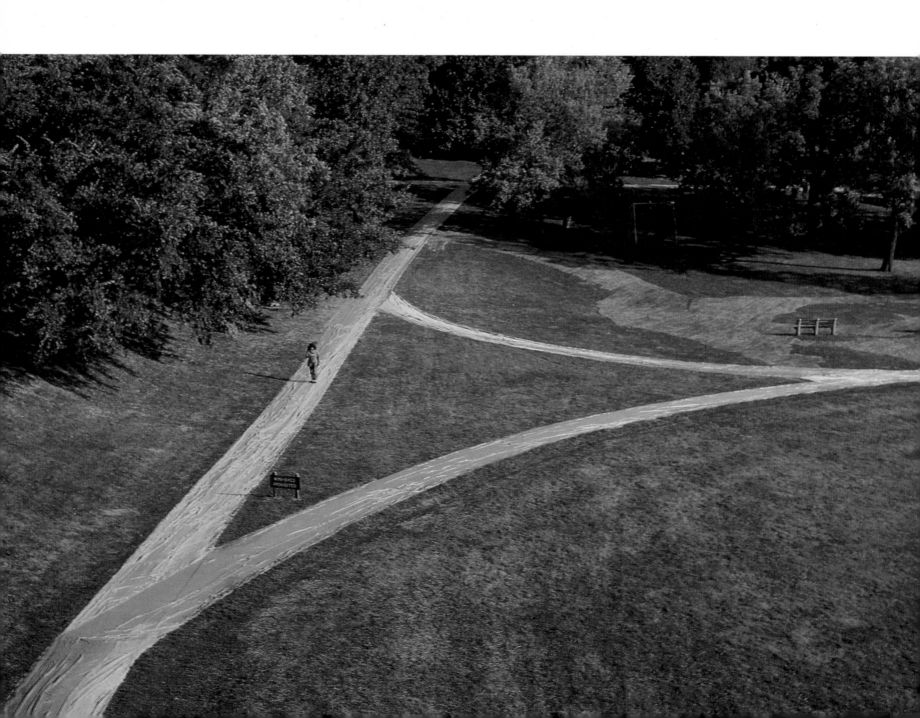

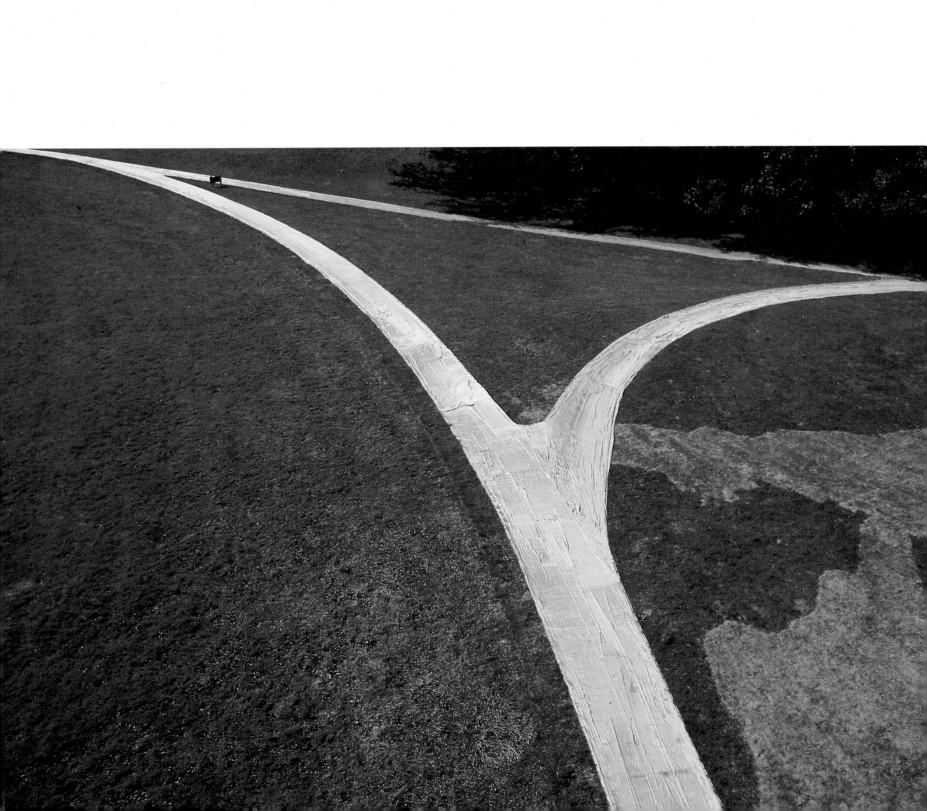

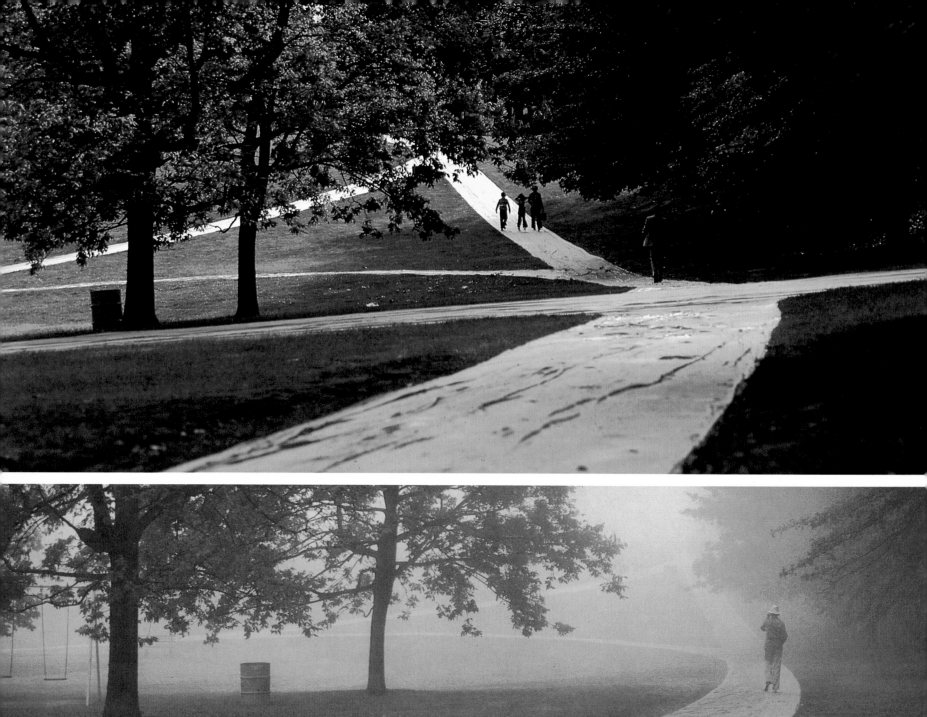
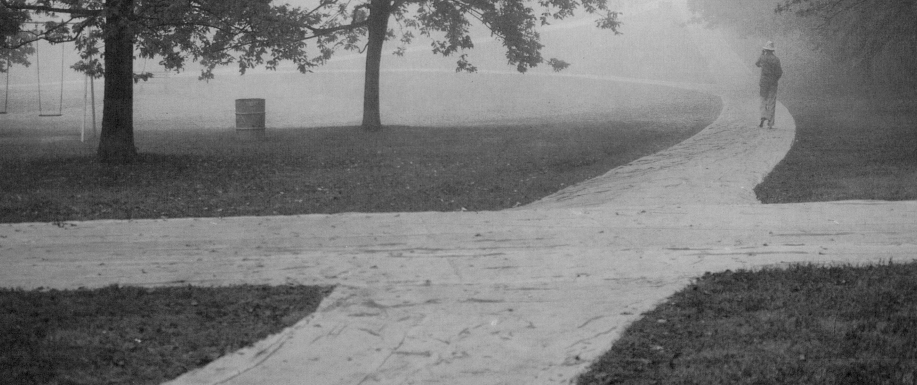

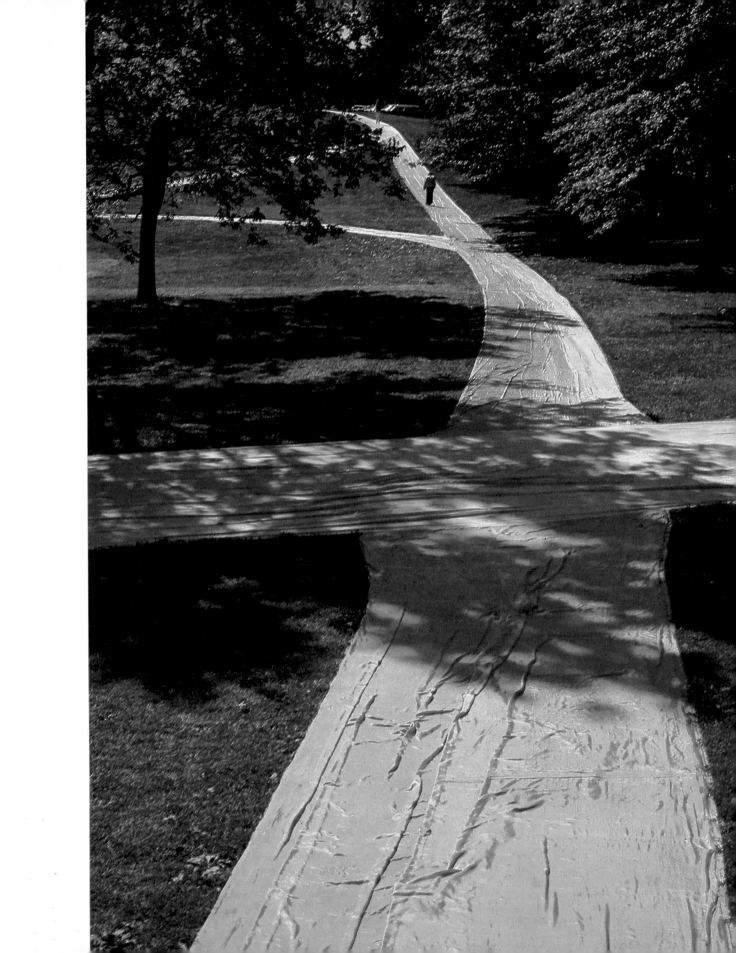

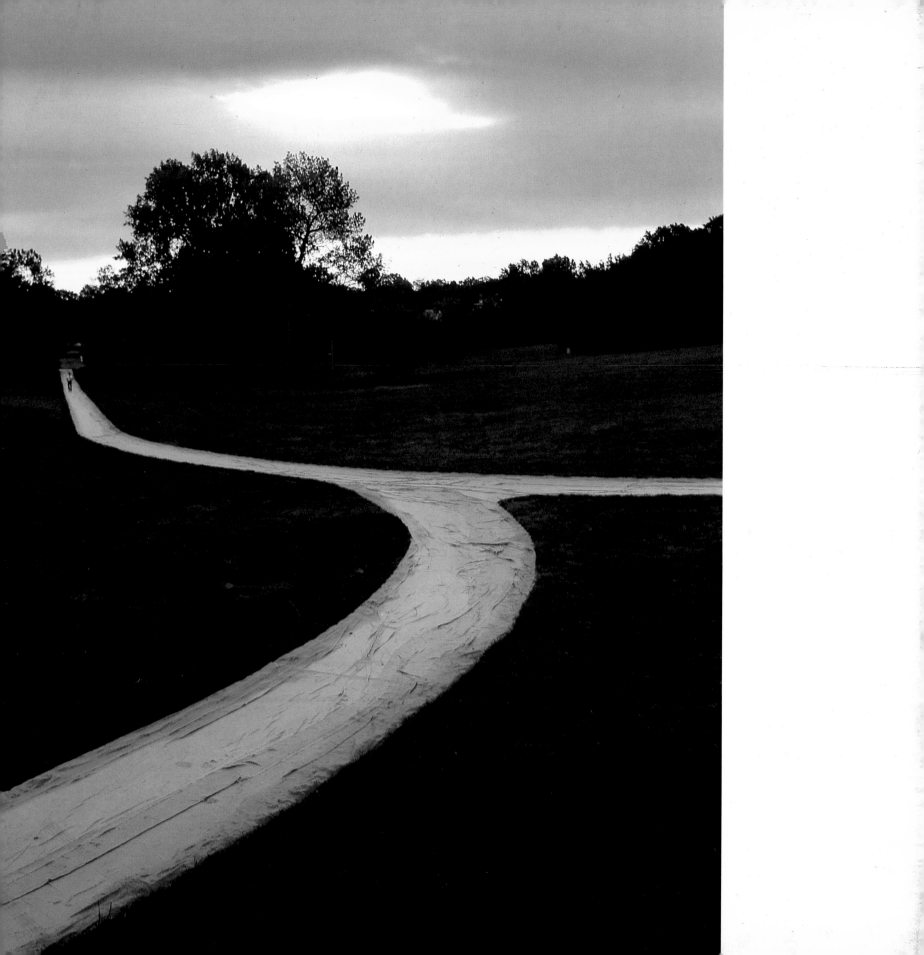

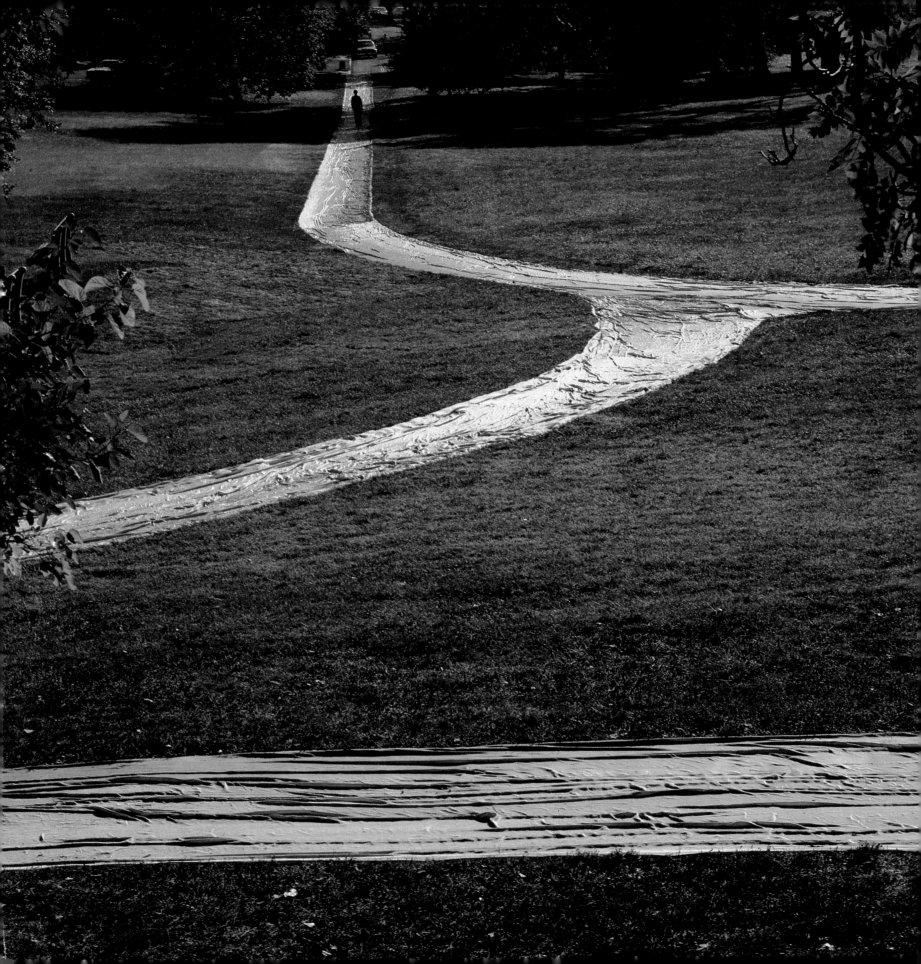

Wrapped Walk Ways

Loose Park, Kansas City, Missouri

Christo
48 Howard Street, New York, New York 10013
Phone 212/966-4437

Jim Fuller Project Director
51 Cliff Street, Nahant, Massachusetts 01908
Phone 617/581-1900

October 6, 1978

FOR IMMEDIATE RELEASE

 KANSAS CITY, Mo. -- Wrapped Walk Ways, an art project by
Christo in Loose Memorial Park, Kansas City, Mo., consists of
the installation of 136,268 square feet (13,870 square meters)
of saffron-colored nylon cloth covering 104,836 square feet
(10,670 square meters) of formal garden walkways and jogging
paths. Installation began on Monday, October 2 and was com-
pleted on Wednesday, October 4. Eighty-four people were employed
by A. L. Huber and Son, a Kansas City building contractor, to
install the material. Among others, there were 13 construction
workers and four professional seamstresses. The cloth was se-
cured in place by 34,500 steel spikes (7" x 5/16") driven into
the soil through brass grommets in the fabric and 60,000 staples
into wooden edges on the stairways. After over 52,000 feet
of seams and hems were sewn in a West Virginia factory, pro-
fessional seamstresses, using portable sewing machines and
aided by many assistants, completed the sewing in the park.
The Contemporary Art Society of the Nelson Gallery, which was
instrumental in getting the construction permits, is sponsoring
an exhibition of Wrapped Walk Ways Documentation at the Nelson
Gallery-Atkins Museum. The Wrapped Walk Ways project was
paid for totally by Christo through the sale of his original
drawings. Harry N. Abrams, Inc. will publish a book about the
project.

 The project will remain in the park until October 16 when
the material will be removed and given to the Kansas City Parks
Department.

Loose Park, phone 816/531-9847, from September 29, 1978
Scott Hodes, Legal Counsel, 180 N. LaSalle Street, Chicago, Illinois 60601

Printed on Recycled Paper